RYEDALE

THROUGH TIME

Gordon Clitheroe

AMBERLEY PUBLISHING

I dedicate this book to Evie and Nancy, and all of my loving family and friends, for their patience and understanding, and the wonderful people who make up this unique area known as Ryedale; also to Hotch, Marion, Robin, Bram, and finally Bernie Curtis, who was tragically lost on the Pipa Alfa Oil Rig Disaster. I shared many happy hours with you all, walking and discovering the fascinating history that lies within Ryedale.

Front cover images:
Maltongate, Thornton Dale
Two men drive their horse and rulley down the unmade road in 1900. Thatched stacks can be seen in the farmyard on the right. The stack yard has now been replaced with modern dwellings, and a young family walks down the footpath into the busy centre of the village on 20 June 2010.

Back cover images:
Thornton Dale, now known as Thorton-le-Dale.

The photographs are the copyright © of G. Clitheroe, the Trustees of Beck Isle Museum, and Barbara Sokol, daughter of Sydney and Maud Smith, and her family.

First published 2011

Amberley Publishing
Cirencester Road, Chalford,
Stroud, Gloucestershire, GL6 8PE

www.amberleybooks.com

Copyright © Gordon Clitheroe, 2011

The right of Gordon Clitheroe to be identified as the Author of this work has been asserted in accordance with the Copyrights, Designs and Patents Act 1988.

ISBN 978-1-84868-930-5

British Library Cataloguing in Publication Data.
A catalogue record for this book is available from the British Library.

Typeset in 9.5pt on 12pt Celeste.
Typesetting by Amberley Publishing.
Printed in the UK.

Acknowledgements

I would like to thank the following people for their help, advice, and encouragement, and once again for their patience and good humour when I arrived on their doorstep. I also wish to thank them for supplying me with information which helped me identify people and locations, for loaning me their photographs and postcards, and for requesting 'just one more book'. I hope you think that our joint efforts have been worthwhile and you enjoy looking at the changing face of Ryedale.

I would like to thank Barbara Sokol and her family for their continued support in my efforts to further promote the work of her brilliant photographer parents, Sydney and Maud Smith, who spent most of their lives recording the changing events and people of Ryedale. I would also like to thank the trustees and management committee of Beck Isle Museum in Pickering for their encouragement and permission to use photographs from the museum's collection; John Rushton and Ron and Margret Scales, for their friendship and encouragement over the years; and other photographers, some unknown, who have recorded images for future generations to enjoy.

I would also like to thank the following: Ian Neil, Stephen E. Botterill, Stephen Roger, George and Ann Turnbull, Harry Dresser, Geoffrey Smith, Mrs D. Ellerby, Ron Holliday, Mrs V. Sonly, Ron Warriner, Sharron Mackley, Brian Nicholson, Eric Bowes, Ian Gibson, Robin Butler, Shane Johnson, Mrs P. Sellars, Mrs D. Wright, Mrs E. Johnson, Mrs Walton, Gary Johnson, Sue Slack, Jean and Geoff Kell, George Robinson, Tammy Atkinson, Charles Wood, Dave Pinkney, Wince Warriner, George Ventress, Ian Patterson, John Richens, Betty and Martin Blythe, Joanna Clayton, Kate Jones, Eric Richard Smith, Brian Fussey, David Hesketh, Denis Woodley, Andy and Cheri Lund, Derek Carr, David and Barbara Whitehead, Stuart Hill, Lynne Olde, Mrs M. Jenkinson, Mr and Mrs Simpson, Alan Bradshaw, Laurie Thackray, David Cousins, Nicola Parker, Dave Harper, Nick Gibson, Stuart Moss, Richard Bowman, Mick Johnson, Margaret Barr, Derek and Mary Webb, Kay Stockhill, Doug Jemison, Ian Wood, Darren Wood, Martin Richardson, Roger Dowson, Robin Mackley, Debbie Wright, Mark Haigh, Mrs H. Sissons, David Bayes, David Hutchinson, Marina Mae, and Mrs T. Hobday.

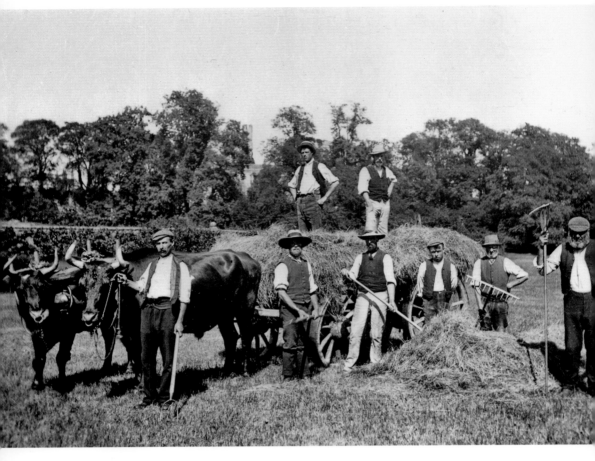

Haymaking in Helmsley
Farm workers are loading a cart pulled by oxen with hay. They were owned by the Duncombe Park Estate, and stabled at Griffe Farm, near Helmsley.

Introduction

Ryedale is a fascinating place made up of small market towns, villages, and hamlets within the beautiful area of North Yorkshire. In the past, each community had its own infrastructure that made it self sufficient; its shops, trades such as the blacksmith and wheelwright, its schools, churches and public houses meant that people did not have to travel out of their own locality. On market day, the local carrier moved farm produce and goods from the villages into the nearest market towns to be sold or exchanged. Goods such as coal and limestone were transported by horse and wagon, until the arrival of the railways, which opened up travel and haulage to cover the whole country.

Two world wars have contributed to vast changes in the way we lived in our rural communities. Gone are the village school, shop, post office, small farms, rural crafts, and tradesmen; most were soon to be replaced with tourism businesses like holiday cottages, restaurants, and gift shops. The horse has been replaced with the tractor, the charabanc with the family car, and we all now shop at the nearest supermarket. The local dialect known as 'Broad Yorkshire' was spoken for hundreds of years in rural communities, but it has now almost died out. Perhaps it is the time to stop for a minute and have a look at the way people lived.

As a small boy I remember going on bike rides with my brother to foreign places called 'villages'. I remember going to Farndale, where I picked a bunch of daffodils for my mother (no longer allowed), Lockton, where I was attacked by a flock (or gaggle) of geese, and Thornton Dale, where I flew over my handlebars (skinning my knees) after running over a tree branch and getting a stick through the spokes of the front wheel.

As a young man I started to explore the beautiful area of the North Yorkshire Moors along with a group of friends on foot, discovering farms, villages, and hamlets, some of which I had never seen before. This was a memorable time in my life, walking in all weathers and making fascinating discoveries most weekends, but I will leave it for others to describe the stunningly beautiful countryside. As the whole area is steeped in history (we discovered inscribed stones in the most unlikely places) I felt compelled to take a deeper interest in the way earlier generations had lived and worked in the community. It would have been good to record something from each town and village in Ryedale, but Pickering and Malton have already had extensive coverage, both by myself and others, and photographic records of other smaller villages have yet to come to light. In this book I have tried to include as wide a range of historical subjects as possible, but please forgive me for any omissions. I am still adding pieces to the jigsaw, and

who knows, your town or village could be the next one to be recorded. I have tried to show modern-day comparisons using colour photography to show what has happened to each site, but when this was not possible, I have tried to use an interesting photograph to illustrate how things have changed. I hope that this book will whet your appetite to explore for yourself the mysteries that are all around you, starting with the place you live; if you require inspiration why not visit the excellent museums that we have in Ryedale, and learn from the photographic records that await you. Meanwhile, enjoy some of my favourite images that I have selected to share with you.

Gordon Clitheroe
2011

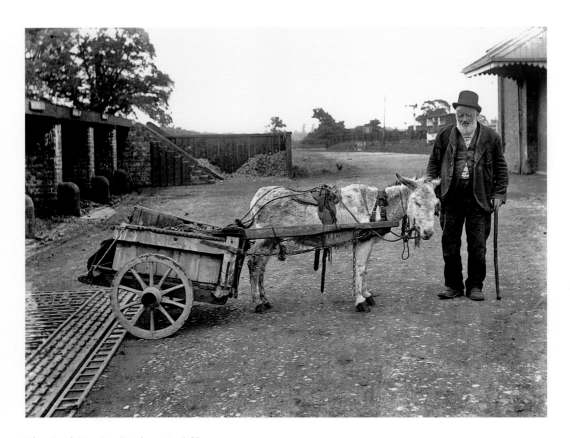

The Coal Carrier (*Sydney Smith*)
This unknown bearded gentleman has just collected a load of coal with his donkey and cart from a coal depot. On the left are the coal cells and behind the cart wheel is the steel weighbridge. A railway signal can be seen on the right.

Chapter 1: Streets and Buildings

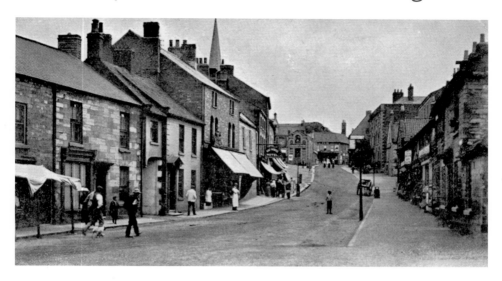

Pickering Market Place

This picture was taken by Boak & Son photographers of Pickering in the early 1900s. The Vaults building can be seen in the centre, and a tree is growing in front of what is now the Conservative Club on the right. On 4 July 2010, a Continental Street Market was held in the marketplace and, as can be seen by the crowds of people attending, it was judged to be a great success.

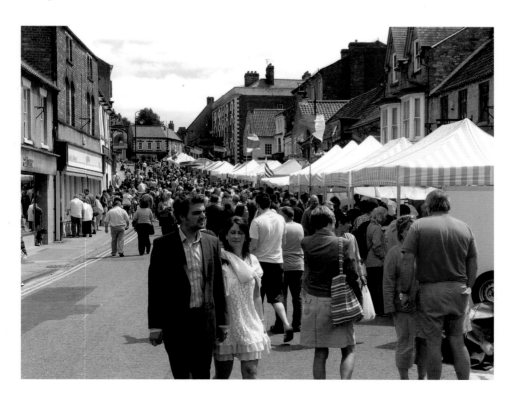

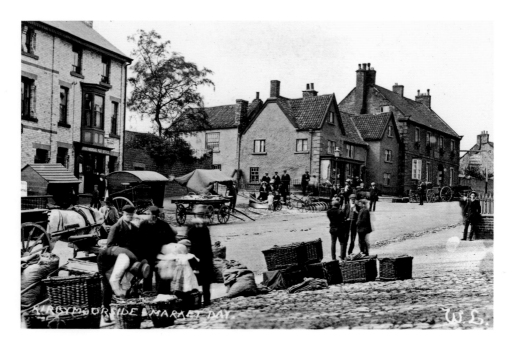

Kirbymoorside Market Day (*Wilf Lealman*)
This photograph was taken before the shop above the post office was built. For many years this area was the site of a water pump, but it has been removed and the site now has flower boxes attached to the railings and bench seating. The town still holds a successful market here each Wednesday. This is market day on 26 May 2010 and we are looking down on the market stalls.

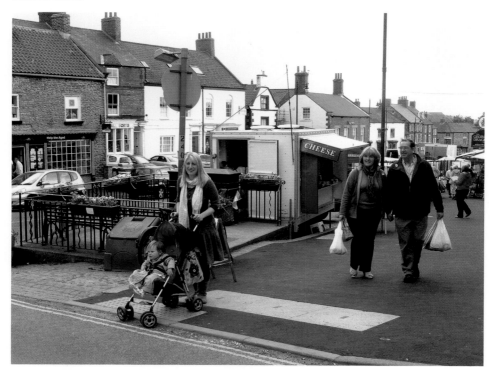

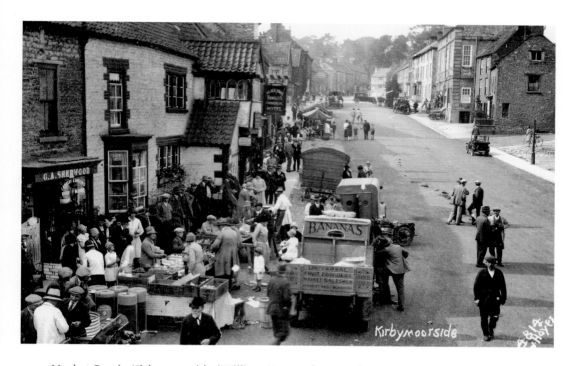

Market Day in Kirbymoorside (*William Hayes of Hutton-le-Hole*)
The lorry looks to be supplying bananas to the fruit stall in front of the Black Swan Hotel, but below we see a stall selling shoes and animal skins for floor rugs. The stall holders are about to pack up their stalls in the afternoon of 16 June 2010 after a sunny day's trading. The Black Swan has now been changed into an Indian restaurant.

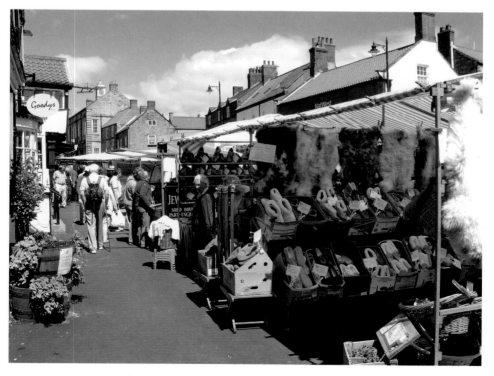

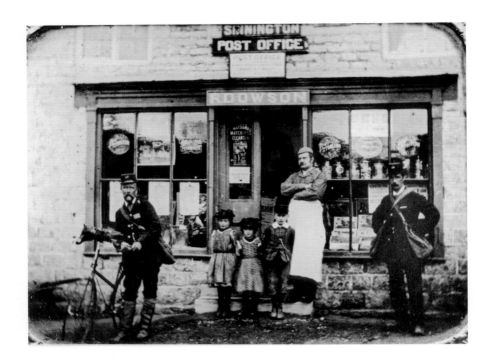

Sinnington Post Office

Two postmen pose each side of what is presumed to be Postmaster R. Dowson and his family, in front of their post office. At this time the post office was also the village store, but later the post office moved further down the village. The village store has now been lovingly converted into Wentworth House. The owner, Mrs Walton, ran the store for a number of years, and is seen receiving a delivery of mail from local postman Gary Johnson on 14 April 2010.

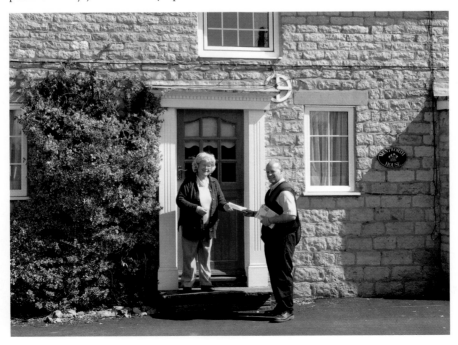

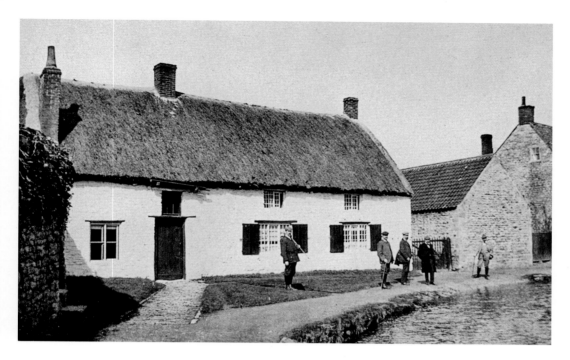

Beck Isle Cottage, Thornton Dale (now Thornton-le-Dale)
A group of gentlemen walkers take a rest at Easter time in 1902. Today this beautiful cottage and its front garden are admired by all the visitors who discover and photograph it. It is the last surviving thatched cottage in the village. Just past the cottage is a quiet little grassed area where children can relax and paddle in the clean water, and parents can rest, while a thirsty dog enjoys a drink from the steam on 20 June 2010.

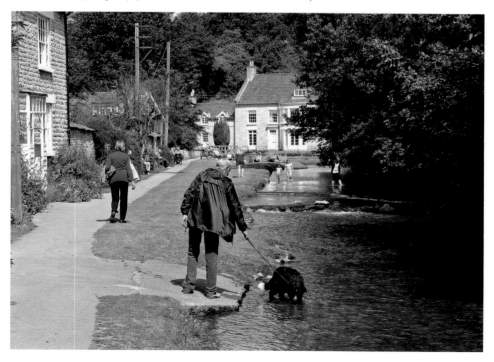

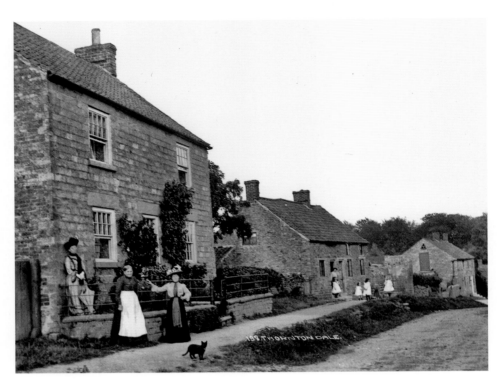

Westgate, Thornton Dale

Ladies, children, and a black cat pose for the camera in 1900. Today, motor cars have replaced ladies posing with, perhaps, their housekeepers in front of their houses, and other cottages have been improved, but the street has still retained its character.

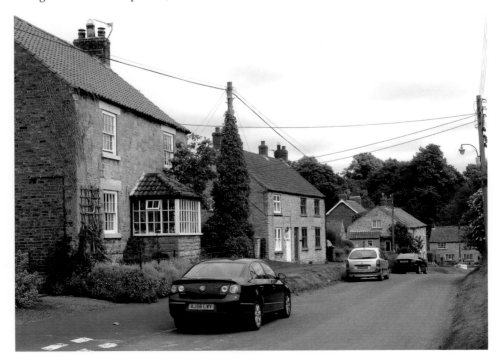

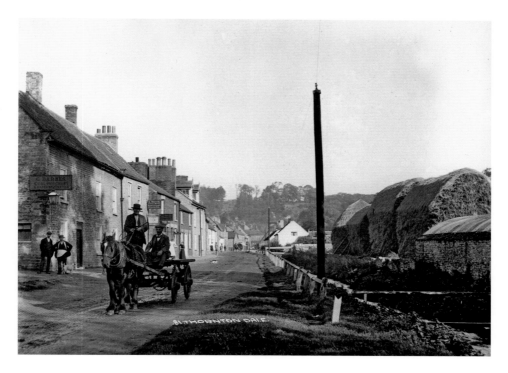

Maltongate, Thornton Dale

Two men drive their horse and rulley down the unmade road in 1900. Thatched stacks can be seen in the farmyard on the right. The stack yard has now been replaced with modern dwellings, and a young family walks down the footpath into the busy centre of the village on 20 June 2010.

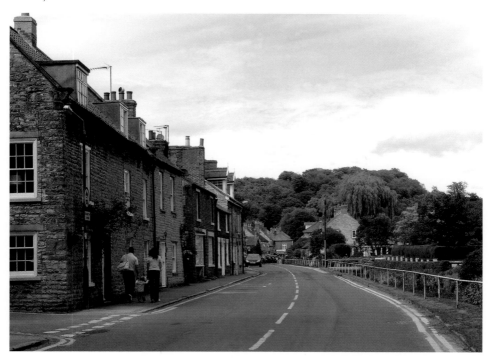

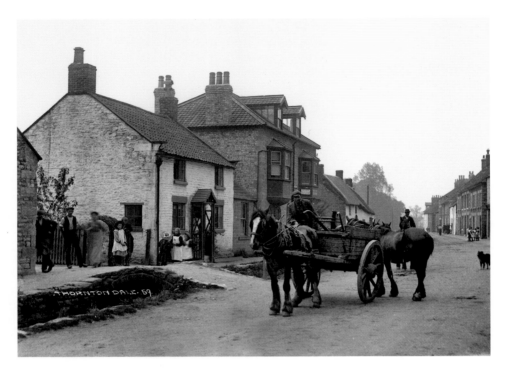

Maltongate, Thornton Dale

A farmer drives his horse and block cart, with a horse tied behind, while men and children look on in 1900. Today the street is busy with cars parked on the right, while on the left visitors relax on the wall in front of the old blacksmith's shop (now the chocolate shop) in June 2010. The large house on the left has been turned into a pharmacy, with a post office next door.

The Durham Ox Public House, Lockton

A group of gentlemen walkers rest outside the pub at Easter 1902. This was one of two pubs in the village, and the landlord, who was also the blacksmith, was called Thompson. The stones to the right of the door are a mounting block, used for getting on and off your horse. Today the pub has been closed for a number years and is now a lovingly restored family home. On 3 May 2010 we can see neighbour Sue Slack, owners Jean and Geoff Kell, and local farmer George Robinson standing in front of the old public house.

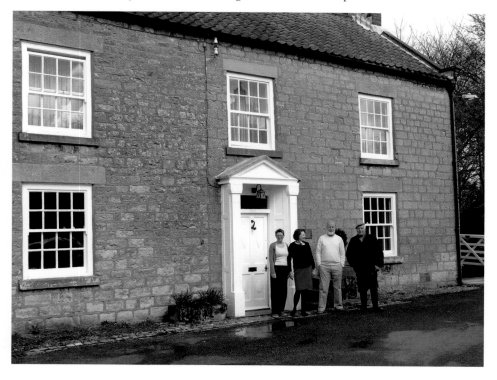

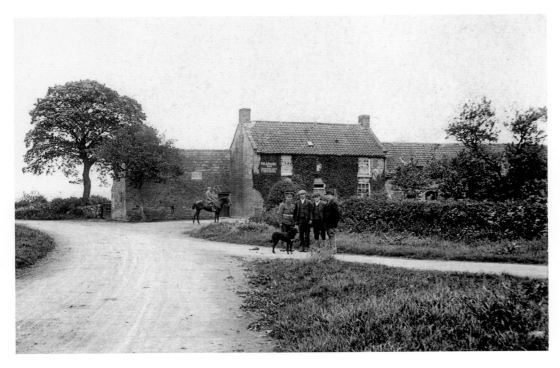

The Fox & Rabbit Inn, Lockton, near Pickering (*Sydney Smith*)
A soldier from the First World War is standing outside with a dog, along with some friends. In the background is a man on horseback. Now, in April 2010, visitors enjoy their lunch, using the outside tables, while soaking up the sunshine at the same time. The inn is very popular, as it is on the road between Pickering and Whitby.

Levisham Village

The steam road-roller which was owned jointly by Pickering Urban and Rural District Councils, and worked in the villages as well as within Pickering town, is seen making a stop to refill with water. The roads were not asphalted at the time, so potholes were just filled with limestone and crushed level with the roller. Today, this farming village still has a thriving public house, which relies on tourists and hikers for its trade, but has become a lovely quiet backwater on the edge of the North Yorkshire Moors.

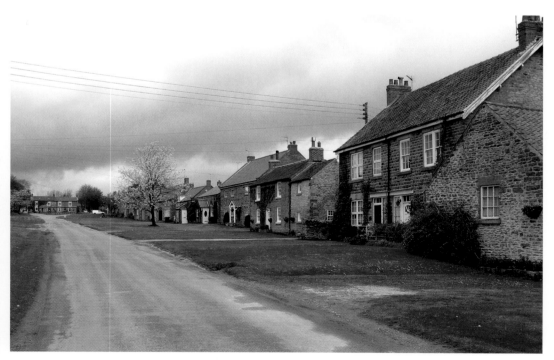

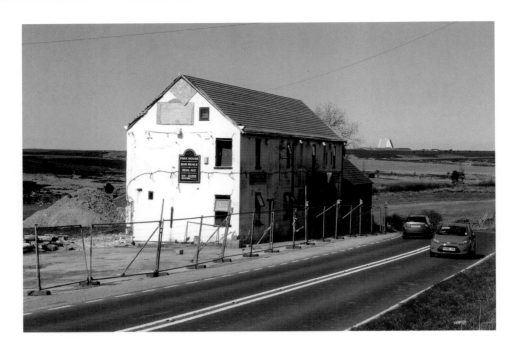

Saltersgate Public House

This pub was formerly called the Waggon & Horses, and lies between Pickering and Whitby. Cars and coaches are parked outside and we do not know whether the occasion was Saltersgate Show, which was held nearby, or simply travellers stopping for refreshment. Today the inn is closed. Work started on a renovation of the whole site; the roof was removed and covered in a blue plastic sheet, but the builders have now left the site. Everyone is hoping that they will soon return, as the building is in the heart of the National Park, and is now looking very sad and fragile. RAF Fylingdales can be seen on the horizon to the right on 21 April 2010.

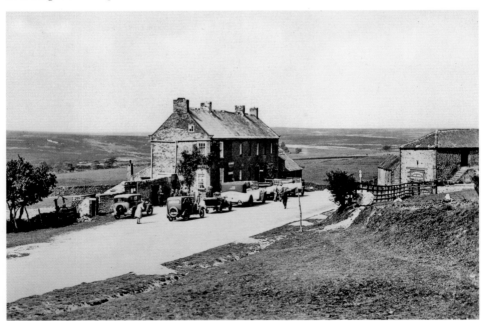

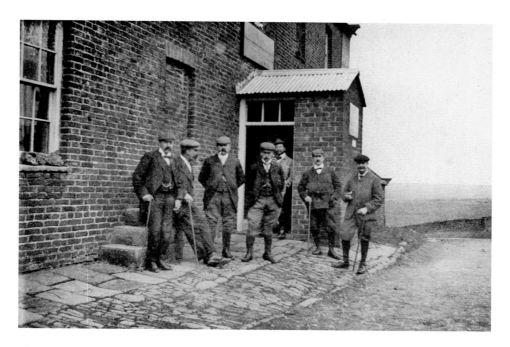

The Waggon & Horses Public House, Saltersgate

Our group of walkers pose in front of the pub, at the side of the Pickering to Whitby road. Two men rest against the mounting block in Easter 1902. Today the pub has closed down, and we have moved a short distance across the moorland path to the Horse Shoe Inn at Levisham on 21 June 2010, where waitress Tammy serves landlord Charles Wood a refreshing pint of beer on the village green in front of the inn.

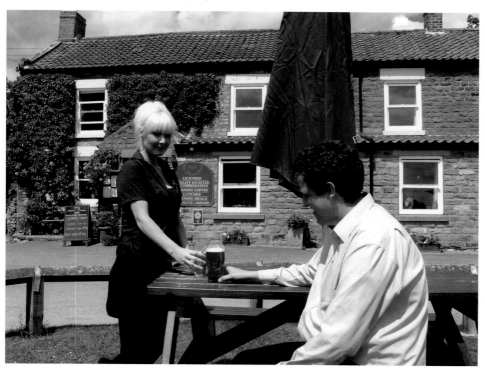

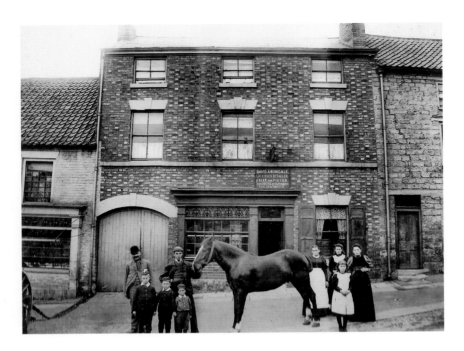

The Lettered Board Public House

Landlord David Arundale and his family pose with their horse in Pickering. The pub was also a butcher's shop and meat hooks can be seen in their shop window on the left. The bar was in the room to the right of the front door, where beer and porter was sold at night. The pub also sold meat from their horse-drawn cart by day. The shop to the left of the pub was also a butcher's, and was owned by a family called Ventress. We can now see the public car parking area in front, and a charity shop on the left, while customers Dave Pinkney and 'Wince' Warriner take a break from their refreshment by stepping outside into the sunshine on 11 April 2010.

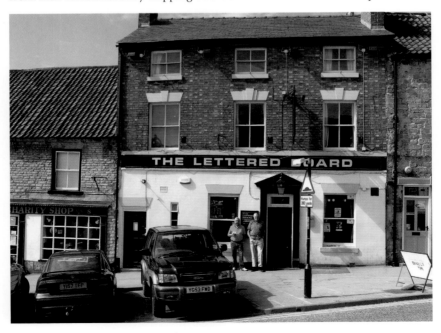

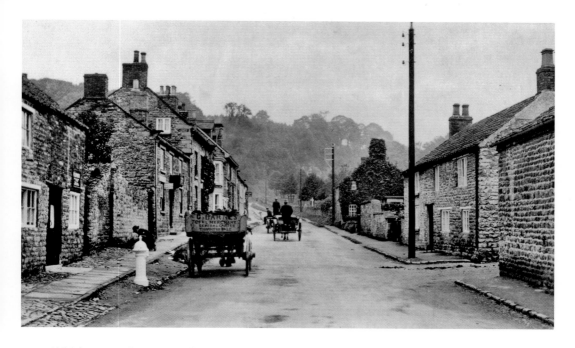

Whitbygate, Thornton Dale

G. Barnes coal merchants are delivering coal with their horse and cart. On the left is Frank Hunton, weeding the path, and in the distance are Mr Barnes with a horse-drawn trap, and Billie and Ernie Raw can be seen on a flat cart. The street now has tea rooms, restaurants, and a new medical surgery. On 15 June 2010, a tractor drives up the road while window cleaners or decorators work up the ladder on the house with the bay windows.

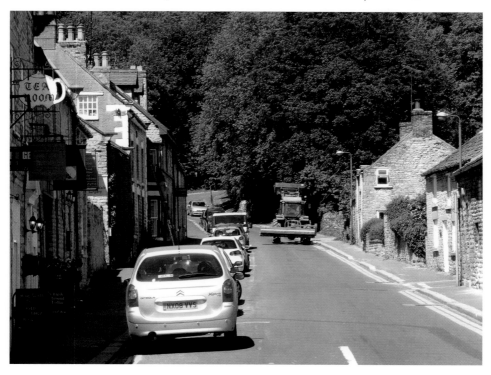

High Street, Thornton Dale

A bearded man poses below with his horse and cart. The name on the cart is William Nellis of Thornton Dale. It is thought that he was a rag-and-bone man who lived in Maltongate in the village. Five unknown children are seen in the background. The railings have survived, but the windows and doors have been replaced. George Ventress, owner of the cottage on the left, sits in his garden while his dog guards the front gate, July 2010.

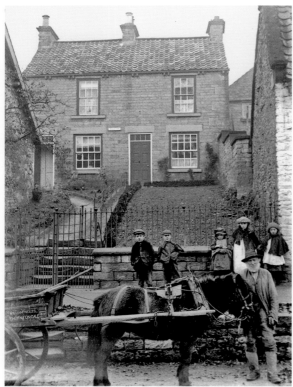

Chapter 2: People at Work

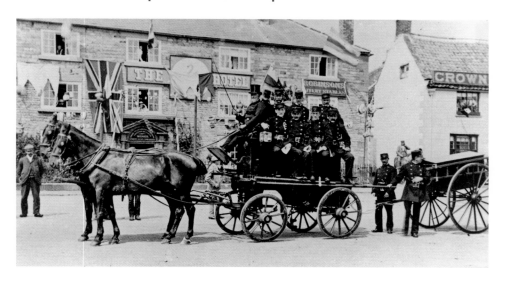

Helmsley Fire Brigade

The Helmsley horse-drawn fire engine with its crew and hand pump are outside the Black Swan Hotel, with the Crown Hotel on the right. Flags are flying so they could be taking part in a parade. On 27 February 2010, the Helmsley fire station held a Recruitment and Awareness Day in order to increase the number of its retained firemen. Station officer Ian Patterson and his men stand by their fire engine at Helmsley fire station in Station Road.

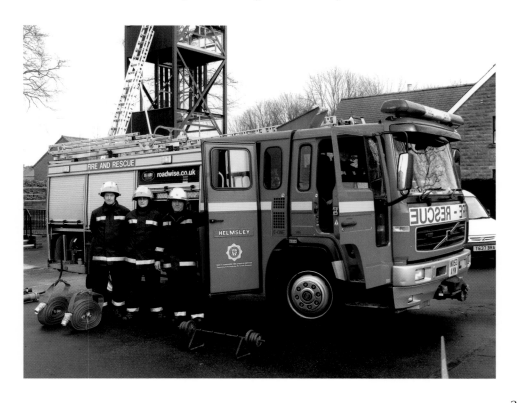

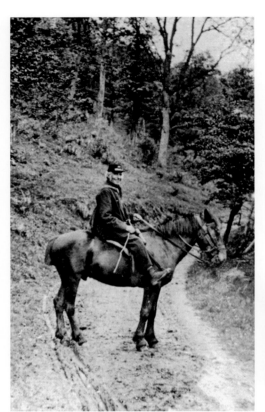

Postman on Horseback

Helmsley postman Tom Richardson is seen delivering the mail to Rievaulx village, near Helmsley. As we cannot recreate the same scene, I have shown a thatched cottage in the village on 24 June 2010 that perhaps would have been served by the same postman. We can also see four Royal Mail vans are parked up in Kirkbymoorside after a hard day's work.

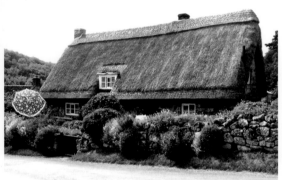

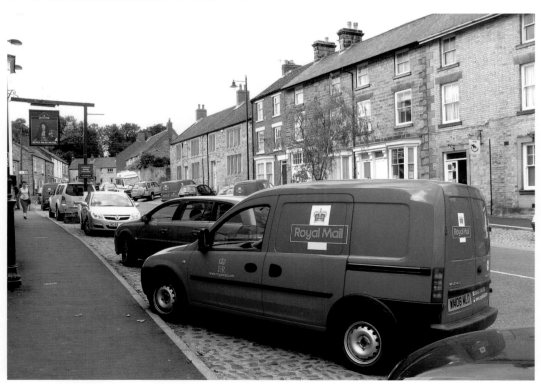

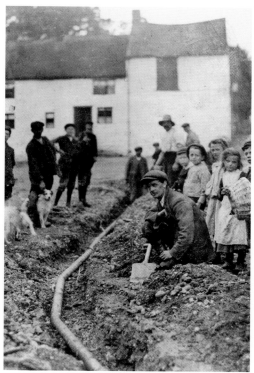

High Market Place, Kirbymoorside (*Wilf Lealman*)

Workmen are laying gas mains in Kirbymoorside in 1907 in this picture taken by Wilf Lealman of Kirbymoorside. The man in the foreground is Benny Blackburn, and the one in the trench behind him is N. L. Rivis. On 2 May 2010, the eighth Beadlam Charity Tractor Run passes through the town. Two hundred tractors took part, covering a 50-mile route through nineteen local villages. This annual run raises thousands of pounds for the Yorkshire Air Ambulance Charity.

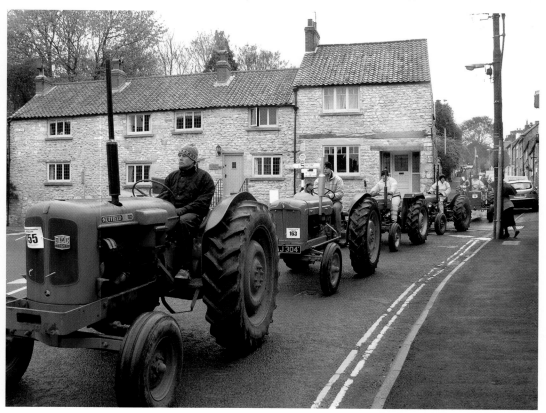

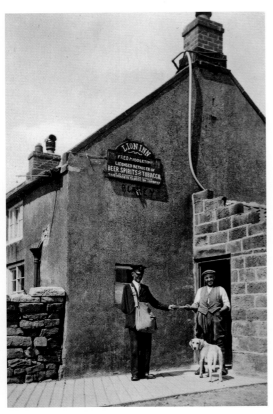

The Lion Inn, High Blakey

Mr Tom Blades, the one-armed postman from Rosedale Abbey, is delivering mail to the public house between Hutton-le-Hole and Castleton. The landlord at the time was Mr Fred Middleton. The inn in recent times has been improved and extended by all its recent owners, and although in a remote location situated between the villages of Hutton-le-Hole and Castleton, it is always well supported by passing tourists and the thousands of walkers who explore this magnificent part of the North Yorkshire Moors National Park and seek refreshment. The modern photograph was taken on 18 May 2010.

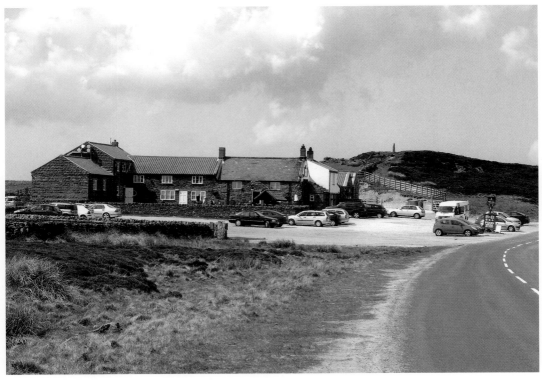

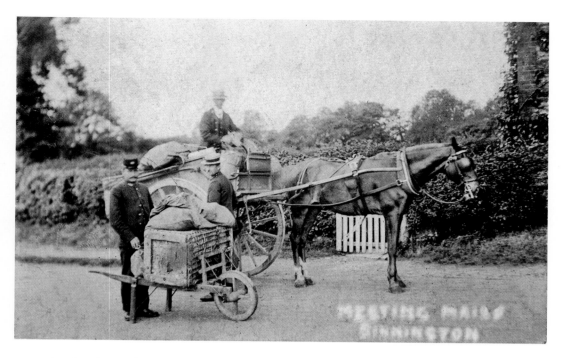

Meeting the Mail at Sinnington

Bags of mail are being taken from the horse-drawn trap and loaded onto the postman's wheelbarrow. The date was 1905. On 1 May 2010, postman John Richens delivers the mail to Sinnington village with his red van.

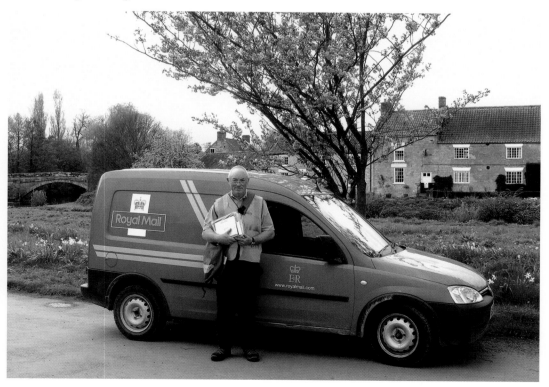

The Old School (*Thomas Smith of Rosedale*)

The old home (below) in the Gill known as Venems Nick, Thorgill, near Rosedale. It was used as a school in the 1860s, and the schoolgirls pose with their sheep dog. The school has since been demolished and Thorgill village is now a quiet little hamlet. On 3 July 2010, three hikers have come down off the moor and are walking through the top of the village on their way to Lastingham.

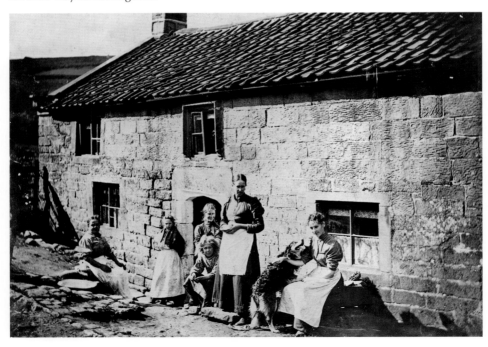

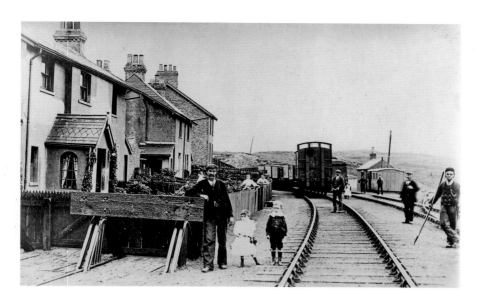

Blakey Junction

This shows the workers' cottages and gardens, along with workers, women and children, on the Rosedale Ironstone Railway. It was used to remove the iron ore from the Rosedale mines across the moors to Battersby Junction, and then onto the Whitby to Middlesbrough line, in order to be used in steel-making mills at Consett and Ferryhill. In total, 11 million tons of ore were transported across the moor before the mines closed down in 1926. Today, the houses and workings have all gone at Blakey, and the moor has returned to its natural state, so we have to visit the North Yorkshire Moors Railway at Pickering station in order to see a steam locomotive named *Repton*. Beth, the driver or fireman, was in charge as the engine came to a halt. The date was 13 June 2010, when the railway took part in the town's 1960s festival.

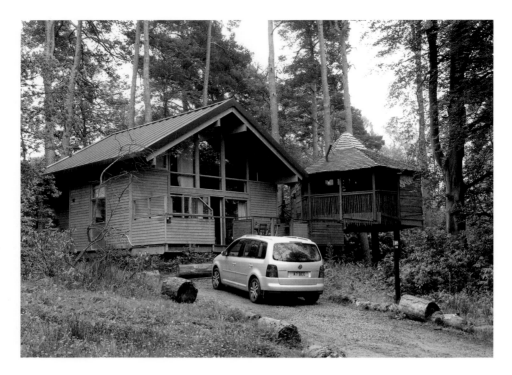

Keldy Castle (*Sydney Smith*)

Building workers, thought to be from W. Ainley of York, are shown below working on Keldy Castle near Stape in 1910. The grounds were used for many years as a venue for Stape Show. At the time it was the home of the Reckett family, but most of the house was demolished in the 1950s. The land is now owned by the Forestry Commission, which has fifty-nine holiday cabins built on the site of the old house. They are run by a company called Forest Holidays, who have sites throughout the country. All are set in beautiful forest locations. Here we see cabin number 14 with its adjacent tree house. The photograph was taken in the rain on 7 June 2010.

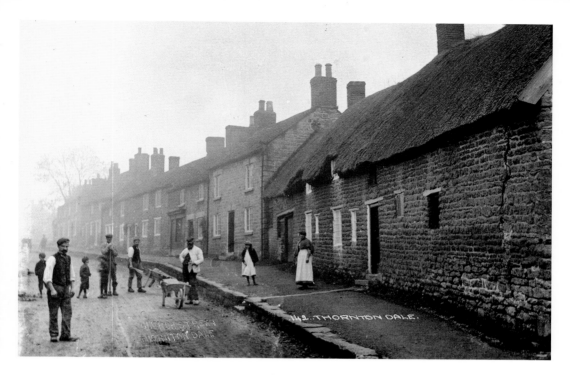

Road Repairs

Workmen with wheelbarrows full of limestone are filling up holes in the highway at High Street, Thornton Dale, watched by a woman in front of her thatched cottage, and school children, in 1900. Today (June 2010) the road is busy with traffic as this is the main road from Pickering to Scarborough, but no one is using the footpath.

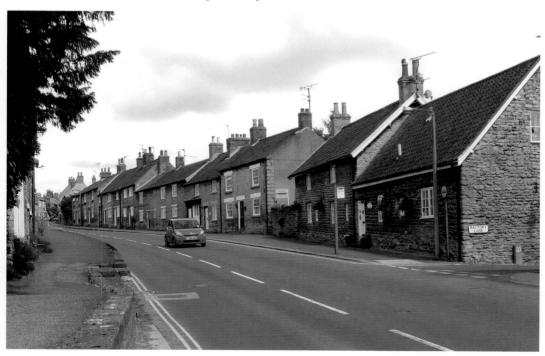

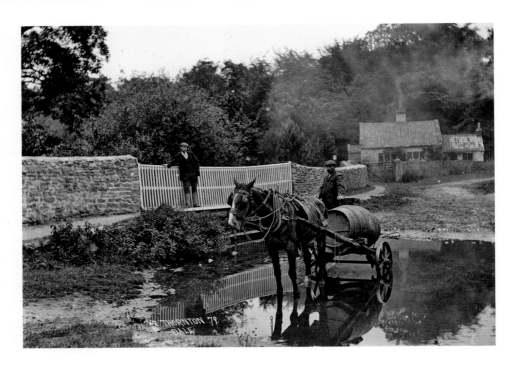

The Water Carrier

A workman is seen in a stream with his horse and water cart made from a large barrel in Bottons Lane, Thornton Dale. They not only supplied water for domestic use, but also sprayed water onto the limestone-surfaced roads in order to keep down the dust on hot summer days. The cottage is called The Old Lodge, and owners Betty and Martin Blythe are standing on the bridge, while Joanna Clayton cools down in the stream with her dog Daisy on 12 April 2010.

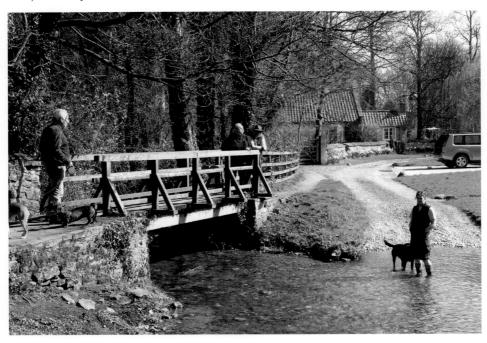

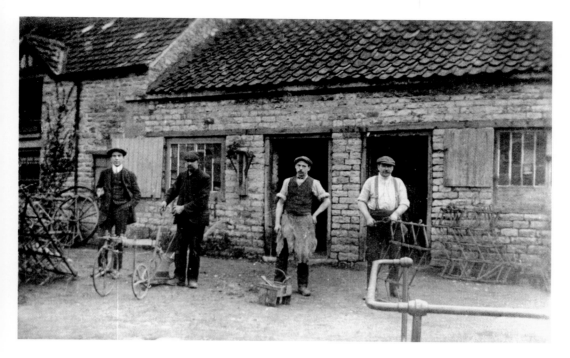

The Village Blacksmiths

The two blacksmiths on the right are Charles William Roger and Edwin Hudson Roger, standing outside their blacksmith shop in the centre of Thornton Dale. The railing on the right is on the edge of the stream in Maltongate. The left of the forge is now a café, while a chocolate shop is on the right. In the photograph below, taken on 20 June 2010, we can still see a horse shoe and a tool for bending steel hoops attached to the front wall, on the left of the café door.

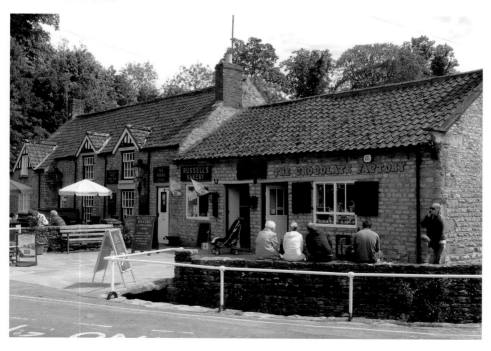

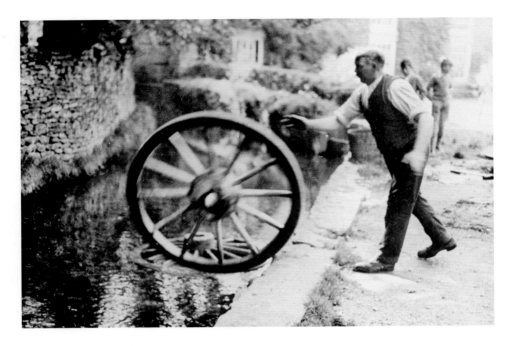

Thornton Blacksmith

Edwin Hudson Roger is rolling a cartwheel into the stream outside his blacksmith shop. This practice was used to swell the joints in a wooden wheel, which tended to become loose over time due to the wood shrinking, but it was only a temporary measure. It could also have been the practice to cool off the steel tyre (or hoop) after the red-hot hoop had been shrunk onto the wooden wheel. On 20 June 2010, customers enjoy a snack at the tables outside the café, and next door is a shop selling locally made chocolate, while trout still swim in the clean water below.

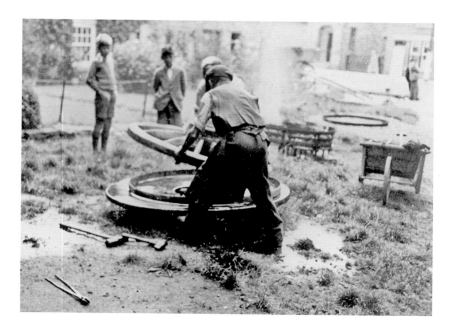

The Hooping Plate

Blacksmiths (thought to be the Rogers brothers) try a wooded cartwheel onto a steel hoop in order to check its size. The wheel would then be clamped onto the cast-iron hooping plate before the steel rim or hoop was heated in a fire until red-hot and then hammered onto the wheel. It was then cooled with water in order to shrink it tight onto the cart wheel. The photograph was taken outside the blacksmith shop on the village green in Thornton Dale. On 11 July 2010, we have the Little Big Band, entertaining visitors with their music on the village green. The little girl sitting on the village cross claps her hands in tune to the music while the man with the ponytail enjoys his ice cream.

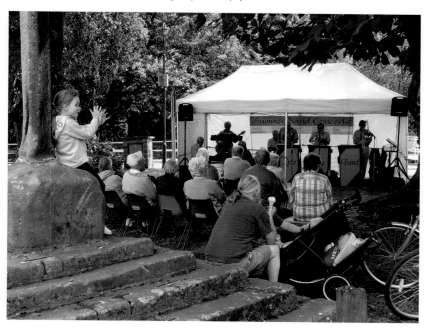

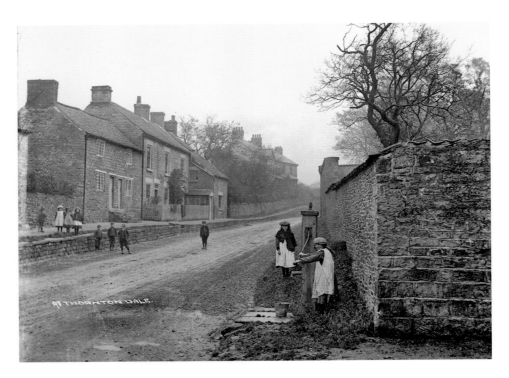

The Village Pump

Schoolgirls fill their bucket with water from the pump at the top of High Street, Thornton Dale, watched by other children in 1900. Today, the pump and children have gone, and on the right builders receive delivery of a lorry load of concrete. This photograph was taken on 2 July 2010, while the traffic streamed past.

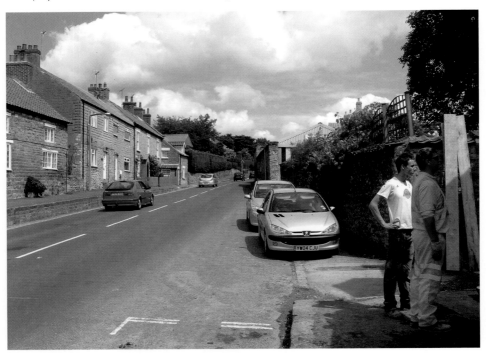

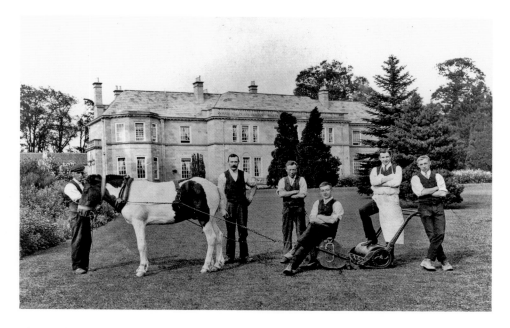

The Gardeners

A group of men are cutting the lawns in front of Kirkdale Manor, Nawton, near Helmsley, using a pony to pull the lawnmower. They are thought to be, from the left, Noel Wilson Sharples, Duncan ?, George Cass, Fred Cooper, George Thompson, and Ben ? Wane. This picture is thought to have been taken by Sydney Smith. Today, this beautiful house has been turned into apartments, and the lawns are cut by contractors; on 9 October 2010, we can see Martin Richardson, resident gardener, and brothers Ian Wood (on triple-deck mower) and Darren Wood about to start work on maintaining the grounds.

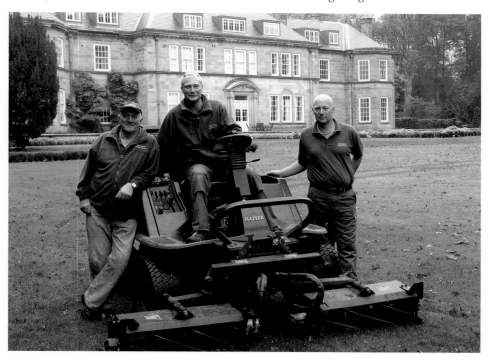

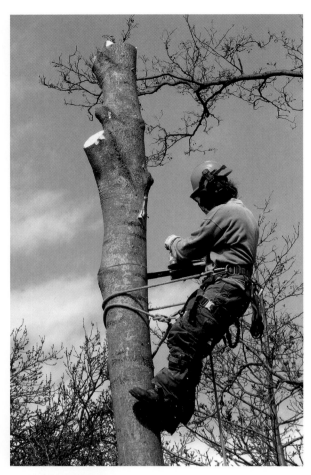

Timber Sawing

Men sawing tree trunks (below) into planks in High Farndale, near Kirkbymoorside. They are using a traction engine and webbing belt in order to power the saw bench. Seven men are working on the timber, which would be normal for this kind of work. The chainsaw has changed our lives forever, and here, on 26 April 2010, we can see a tree surgeon cutting down tree trunks into short lengths. This is due to the confined space at Mill Lane, Pickering.

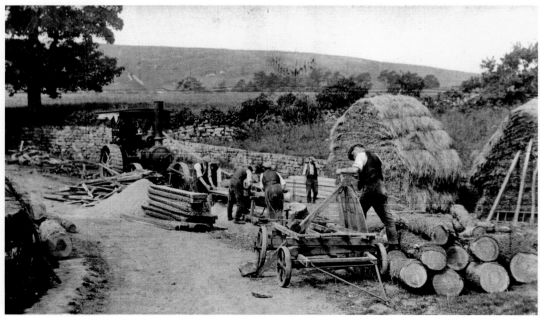

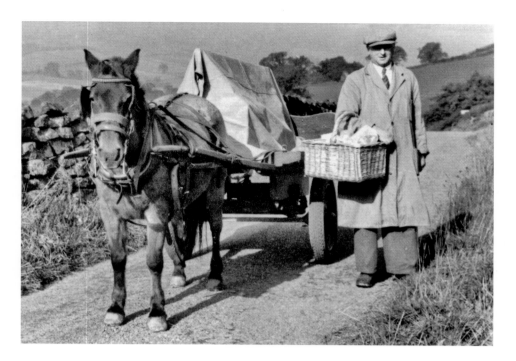

The Mobile Grocer

Herbert Carter of Farndale, near Kirkbymoorside, is delivering groceries to the scattered community of Farndale using his horse and cart and his farm basket. Today, very few mobile shops have survived due to competition from the supermarkets, but this one is owned by David Cousins, who is assisted by Nicola Parker, and they are selling fresh fruit and vegetables at Pickering car-boot sale on 25 July 2010. It states on the van that they still deliver to your door.

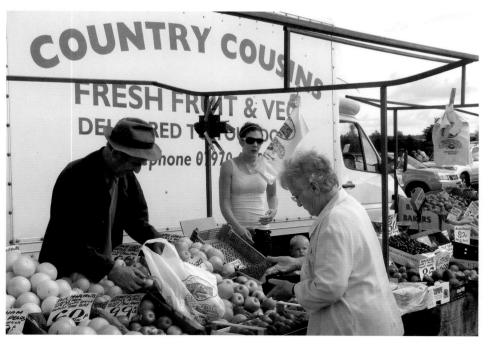

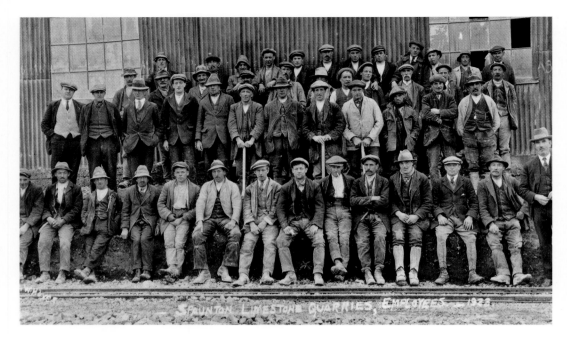

The Quarrymen

This group of workmen were employed at the Spaunton limestone quarries, near Kirkbymoorside, in 1923. Today the quarry still produces limestone and tarmac for road-building works, but it is produced using only a handful of staff. When this photograph was taken on 18 May 2010, no one appeared to be on site.

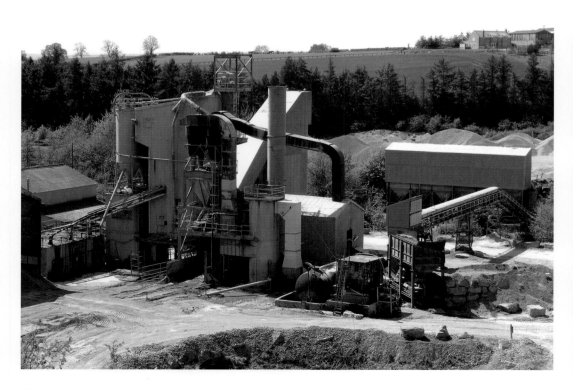

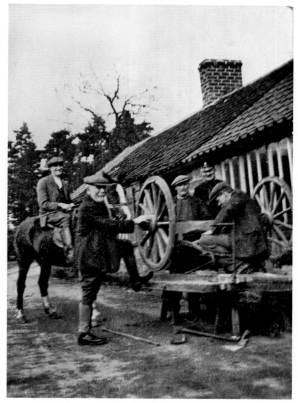

Blacksmith Shop, Rosedale Abbey
A group of men are working on this overturned farm cart outside the blacksmith's shop, watched by the local policeman. The blacksmith's shop has since been transformed into a working glass studio called Gillies Jones, where glass is blown by Stephen Gillies and then decorated by his partner Kate Jones. The glass vessels are turned into the most beautiful works of art, which are on display in galleries and museums, including the V&A in London. The gallery is internationally acclaimed for the high quality of its work. Kate is holding one of their bowls on 11 June 2010, an open studio day.

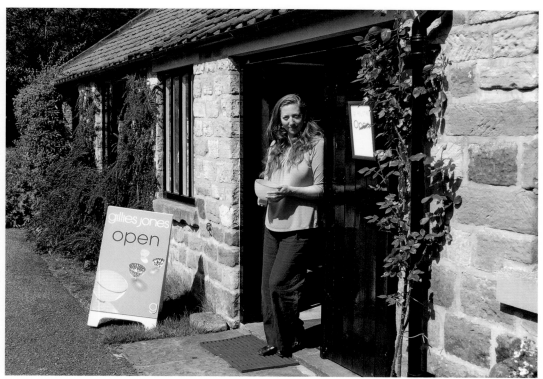

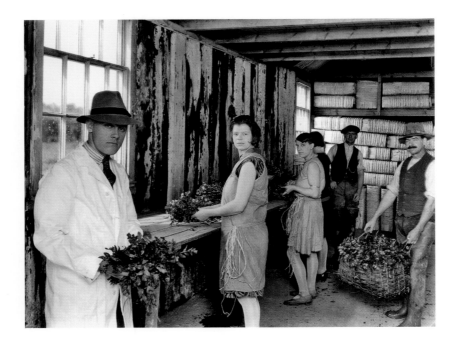

Watercress Workers

Employees of Pickering Watercress Company, which was owned by Mr Fred Hugill Sonley, are packing watercress into crates ready for dispatching by rail to restaurants all over the country in 1929. From the left: -?-, Doris Harper, -?-, -?-, Foreman Jim Harper (in flat cap), and Jack Harper (holding the basket). Today the farm is called Willowdene Watercress & Trout Farm Ltd., and Eric Richard Smith, son of the owners, and Brian Fussey are catching large trout to fulfil an order on 8 April 2010. The fish are sold live to angling clubs, and are used to restock rivers and fishing ponds.

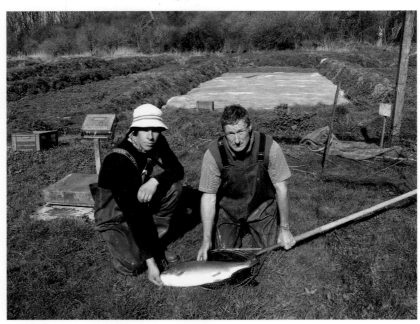

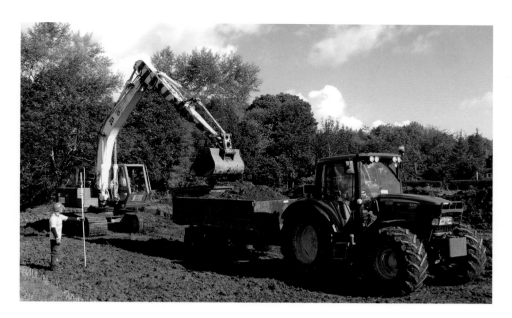

Old River Board

It is thought that these workmen below, complete with a mechanical drag line, were employed by the Yorkshire Ouse River Board. They dredged rivers to prevent flooding and used the removed silt to build flood banks in order to protect farm crops all over the district. From the left: Stan Welburn, Tom Tasker, Stan Ring, -?-, 'Budgie' Ward, Charlie Sugget, -?-, 'Bugsie' Harrison, -?-, -?-, -?-. They had a depot at Great Barugh, near Malton. On 30 September 2010, the Environment Agency staff are excavating a flood alleviation channel at Sinnington village in order to create a flood plain, allowing water to flow from the River Seven across fields, and then under the main A170 highway to reduce flooding in the village. David Hutchinson and colleagues remove topsoil to form the channel. Today, unfortunately, very little dredging or river clearing now takes place, and flooding of towns and villages has returned to Ryedale. It is hoped that the work being undertaken will help to protect the village.

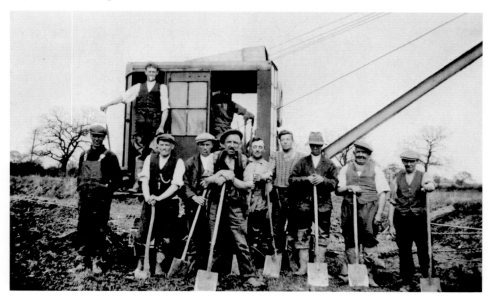

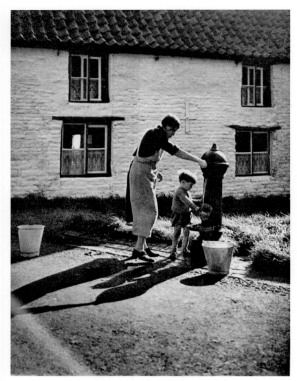

The Village Standpipe (*Sydney Smith*)
Marion Hutchinson and her son John are collecting water from the street stand tap in Wrelton. This was the only supply of clean drinking water for people without a piped supply. This part of Wrelton is known locally as 'Goshen', a biblical name meaning place of light or plenty. Today, the standpipe has gone and the cottages have been turned into two beautiful cottages and gardens. Here we see one of the owners checking the flowers in front of the cottages on 21 June 2010.

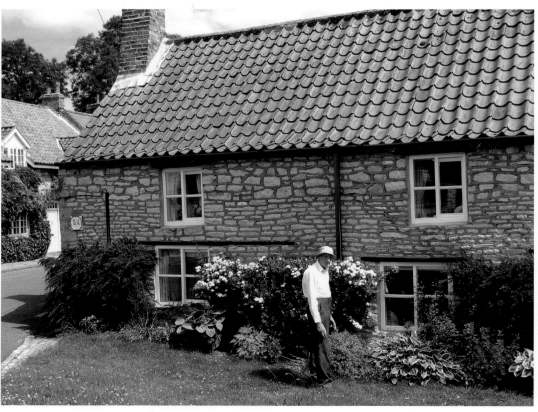

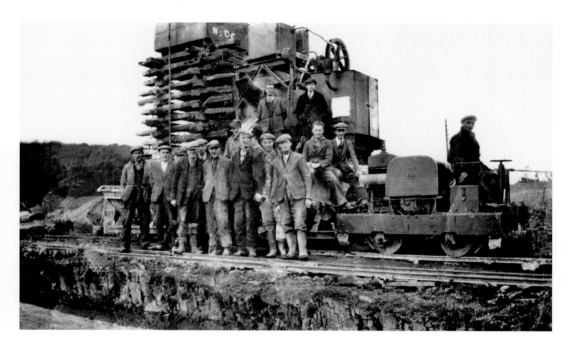

The Road Builders

This group of workmen are building the Sinnington Bypass in 1946. They are thought to be, from the left, G. A. Wood, A. Richardson, -?-, -?-, C. Headley, J. Benson (above C. Ellis), ? McCann, -?-, Bill Bower, Tom Tate, ? Allanson, and S. Humble. We can now see the highway that the workmen created. The road is now carrying large volumes of traffic which would originally have had to pass through the village on the Pickering to Kirkbymoorside road. The beautiful village is now a pleasant place to live in, photographed here on 24 June 2010.

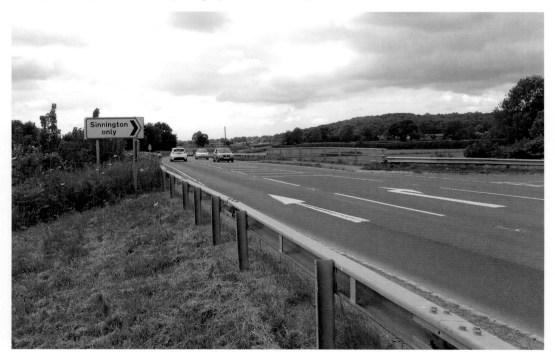

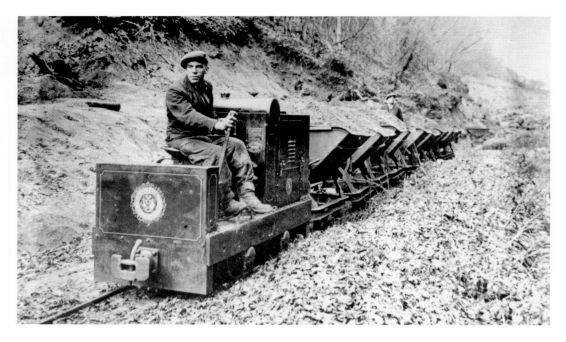

The Sand Quarry Train (*Sydney Smith*)
Jack Marshall of Pickering is driving down the narrow-gauge railway track from the sand quarry at Saintoft to the crushing plant at Newbridge limestone quarry. The sand was used for moulding cast-iron baths, etc. in foundries. Today, the sandstone crushing plant and railway have gone, but the quarry near Pickering is still in use, extracting limestone rock for the building industry and highway maintenance works. Here we can see some of the old buildings at the limestone quarry.

Chapter 3: Farming Life

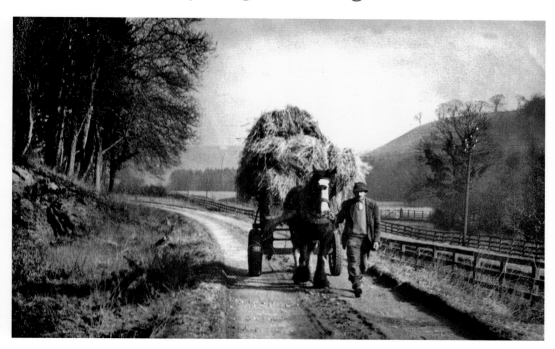

Bringing in the Hay (*Sydney Smith*)
This load of hay was passing the Hunting Bridge, north of Pickering. The driver was C. Hodgson, and the horse was named Peggy. They worked for Mr P. Harrison of Blansby Park, Pickering. On 19 May 2010, we see Denis Woodley driving a heavy horse named Patrick, who was pulling a two-wheeled block cart. Patrick is owned by Mr David Hesketh of Burythorpe, near Malton.

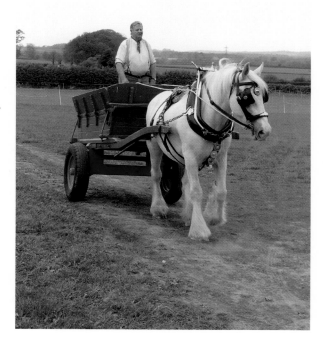

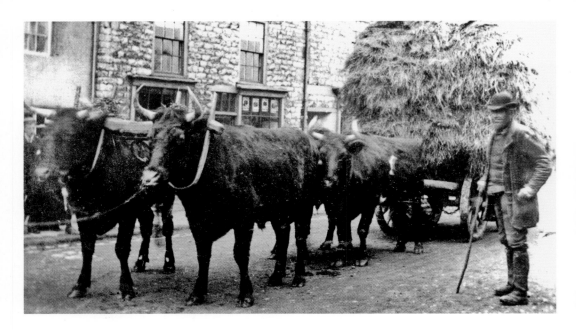

The Oxen Team

Four oxen are yoked to this cartload of straw, or hay, in Helmsley Market. The oxen were owned by the Duncombe Park Estate, and were stabled at Griffe Farm, near Helmsley. Mr David Hesketh is driving his heavy horse called Prince at his home in Burythorpe, near Malton. They are pulling a hay rake on 19 May 2010 as part of a Women's Land Army reunion day that David organised at his farm in recognition of and to celebrate the fantastic part played by the ladies during the Second World War.

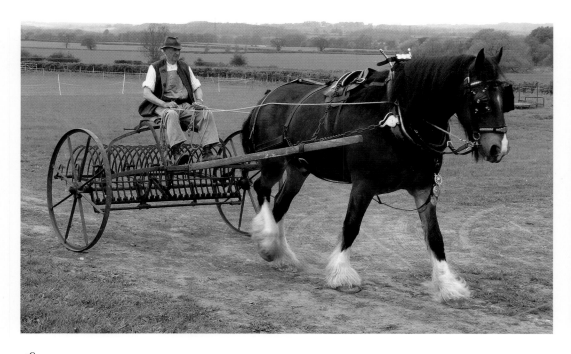

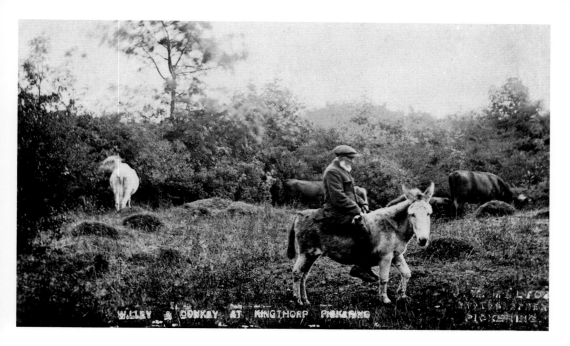

The Cow Tenter (*J. W. Malton, a Pickering Postman*)

Willey 'Tatty' Medcalf, the blacksmith from Lockton, is riding his donkey in order to look after a herd of cows at Kingthorpe, near Lockton. Many households owned one cow and would pay a Cow Tenter to take it out to graze all day, and then return it back home at night. On 11 October 2010, Robin Mackley and his sheepdog Jack are moving Highland cattle on Saltersgate Moor, near Skelton Tower, just a few miles north of Kingthorpe, on the Pickering to Whitby Road.

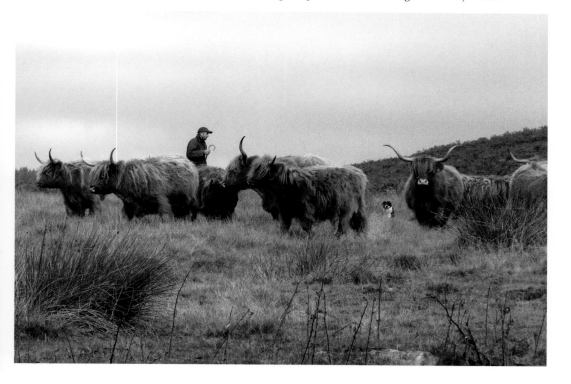

Market Day (*Sydney Smith*)

Tom Hardwick of Vinery Farm, Wrelton, near Pickering, can be seen below riding in a horse-drawn trap and driving a flock of sheep in an area of the village called 'Goshen'. In the picture taken on 21 June 2010, the horse and trap have now gone, along with the sheep, replaced by a motor car, but the pretty village remains unspoilt.

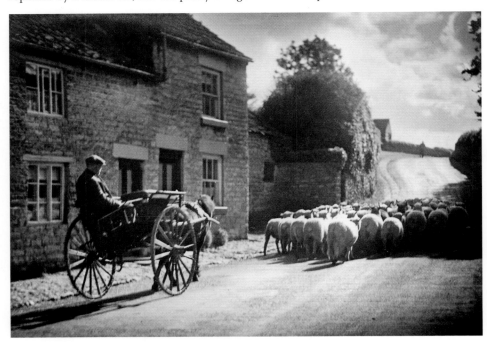

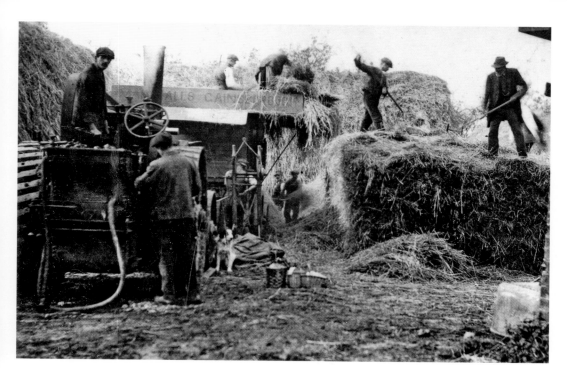

Threshing Day at Tape Barn, Swainsea Lane, Pickering (*Sydney Smith*)
Farmer Mr C. Ellis is standing on the straw stack, while engine driver Mr Ernest Mortimer is on a Marshall of Gainsborough threshing set. The steam engine, No. 19500, is a 6-hp, introduced in about 1895. The farm has now been demolished as Newbridge limestone quarry has been enlarged, taking up the farmland behind. Only a few beehives now occupy the remaining site.

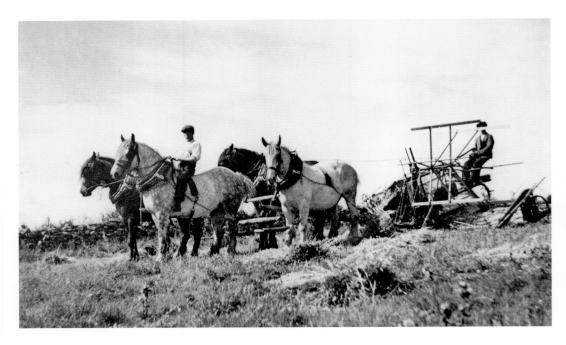

Harvesting with Binder (*Sydney Smith, 1939*)
Farmers George Smith, on the front horse, and his brother Thomas are sitting on the reaper binder; they are cutting corn with four horses at Hall Field, Lockton. They lived at West View Farm, Lockton. The names of the front two horses were Violet and Cobby. On 23 July 2010, Nick Gibson is harvesting with a combine harvester and loading the barley into the farm trailer on Middleton Road, near Pickering. The straw will be bailed later, after all the barley is returned to the farm.

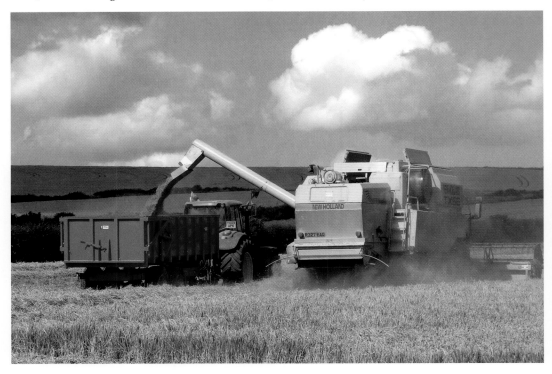

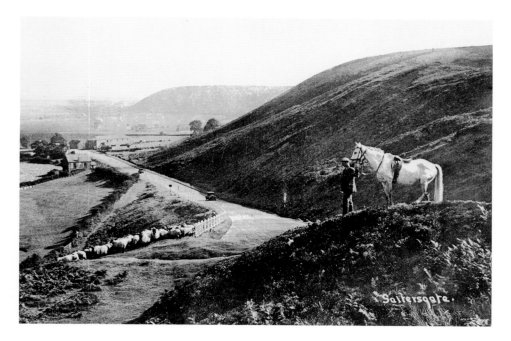

Moving the Flock (*Sydney Smith*)

Farmer Stan Mackley holds his horse at Saltersgate Bank, on the Pickering to Whitby Road. He is moving the flock of sheep on the left. The building at the bottom of the bank was used as a school on weekdays and a chapel on Sundays. Saltersgate public house is just behind. Stan was also Master of the Saltersgate Hunt. On 11 October 2010, Robin Mackley, who is related to Stan, is rounding up a flock of sheep on the Levisham side of Saltersgate Moor, using his sheepdog Jack.

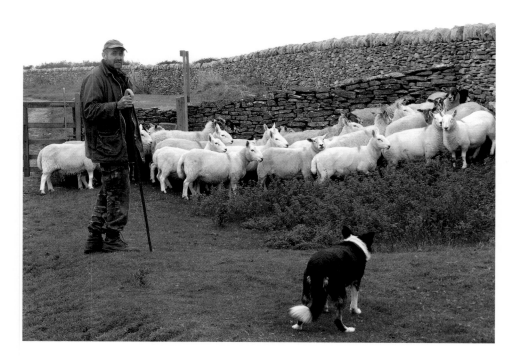

Chapter 4: Sport and Leisure

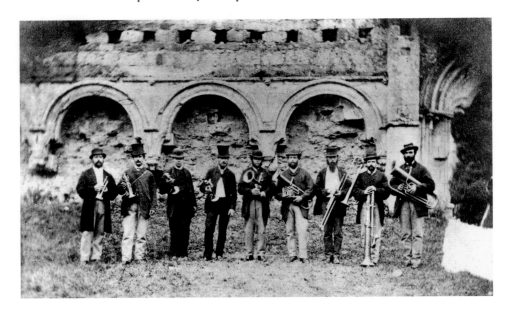

The Town Band

This very early photograph of Helmsley Town Band is not dated, but the members are thought to be known. From the left: Job Burton, Jim Jackson, Robert Hardy, George Moon, Isaac Cooper, John King, Bob Robinson, Tom Hoggart, and Robert King. The town no longer has a band, but on 16 May 2010, Bilsdale Silver Band is playing music for the visitors to Duncombe Park, the stately home in Helmsley. It was cold and starting to rain, so the concert was about to finish.

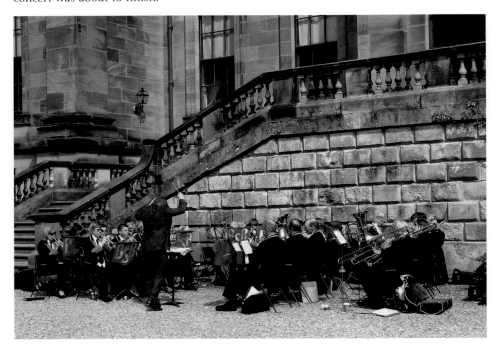

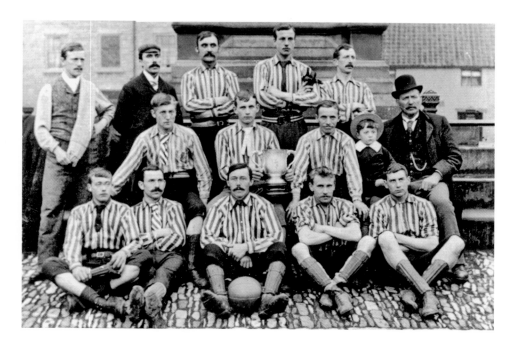

Cup Winners

Duncombe Park Football Club, winners of the Scarborough and East Riding Cup, in 1894. Back row, from the left: H. Robinson, -?- (Trainer), T. Smailes, A. Ward, A. Churnside, ? Chipchase. Middle row: H. Atkinson, A. Spence, ? Cowie, W. Frank, -?- (President, with his grandson). Front row: R. Atkinson, T. Cooper, T. Trenham, -?-, ? Petler. The photographer is unknown. Today, Duncombe Park FC is still playing in Division Two of the newitts.com Beckett League, and on 6 November 2010 they played Thornton-le-Dale Reserves away at the Thornton-le-Dale ground. We see them defending their goal from attack in their red shirts, but unfortunately on this occasion they lost 3–0.

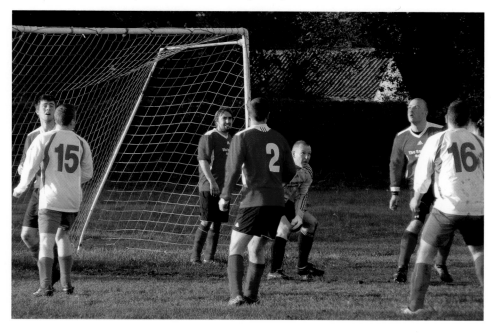

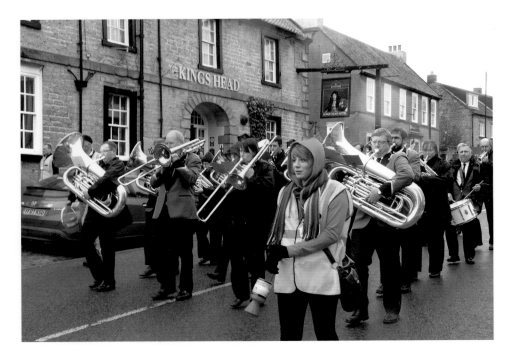

The Otter Hounds

Captain Thompson's Otter Hounds meet below at the Kings Head Hotel in Kirbymoorside before moving off. This photograph was taken by H. Aldine, photographer of Sinnington, and is thought to date in the early 1900s. On 2 May 2010, Kirkbymoorside Town Band march down the main street past the Kings Head in the rain, ahead of the eighth Beadlam Charity Tractor Run. They also played in the marketplace during the tenth Kirkbymoorside 10k Run that took place later on the same day.

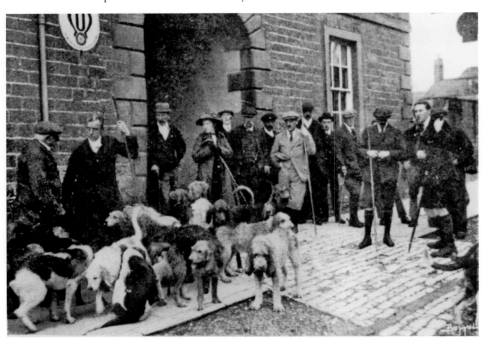

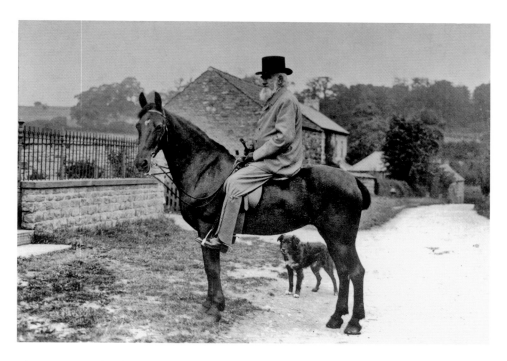

The Horseman (*Sydney Smith*)

This gentleman is riding out with his dog in Westgate, Thornton Dale. This photograph was taken in the early 1900s, when Sydney Smith, photographer of Pickering, was working from his Park Street premises in Pickering. On 15 May 2010, we see a family having a ride out at Dalby Forest Visitor Centre, near Thornton-le-Dale, where people can experience the great outdoors.

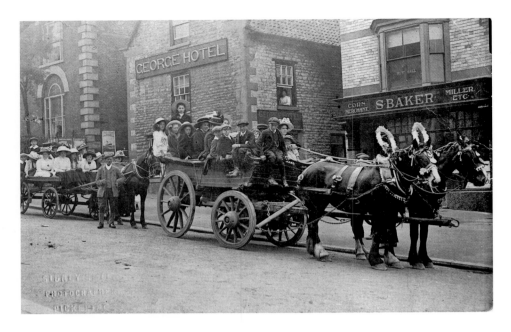

Wagon Outing

This outing is about to set off from outside the George Hotel in Pickering marketplace. The horses are decorated and the children are in their Sunday best, so it could have been a Sunday School treat or a parade. The photograph was taken before 1912. Note the tree growing in front of what is now the Conservative Club on the left. On Remembrance Sunday, 14 November 2010, a parade follows Stape Silver Band from Pickering parish church, where a service had taken place, down the marketplace to the town's war memorial, for a second service and wreath-laying ceremony.

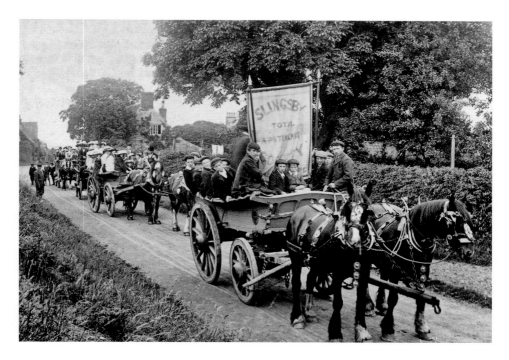

Total Abstinence

Members of Slingsby Total Abstinence, complete with their banner, stage a parade of members within horse-drawn wagons in 1904. They were unsuccessful in banning alcohol, as the village still has a thriving public house. On 30 June 2010, we can see the landlord of the Grapes Inn, Andy Lund, and his wife Cheri, taking a break to chat to friend Derek Carr. The low building on the left once served as a butcher's shop.

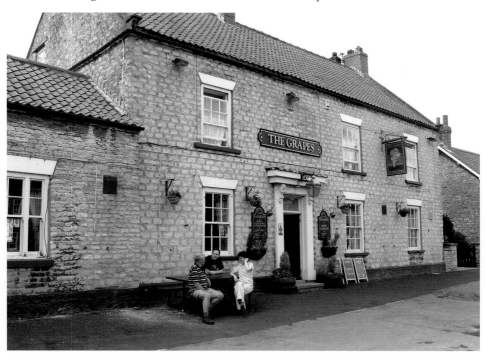

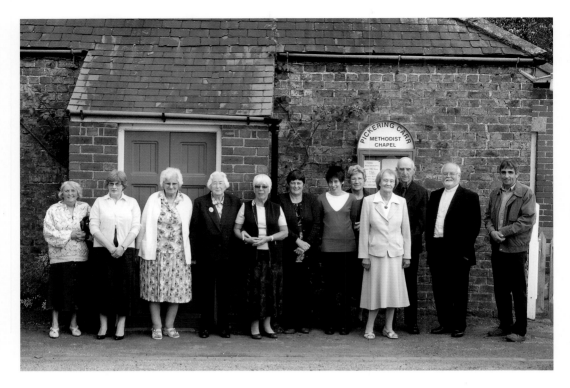

The Sunday School Treat (*Sydney Smith*)

Members of Pickering Carr Methodist Chapel pose in their Sunday best below in 1910, as they enjoy their Sunday School treat. The church is at Black Bull, on the Pickering to Malton road. The outing would take the form of a picnic tea, sports, and open-air service. Just a hundred years later, the chapel held their anniversary service on 18 July 2010. The service was conducted by Mrs Thelma Hobday (in cream suit), and assisted by Revd Peter Cross. The chapel celebrated its 150th anniversary last year.

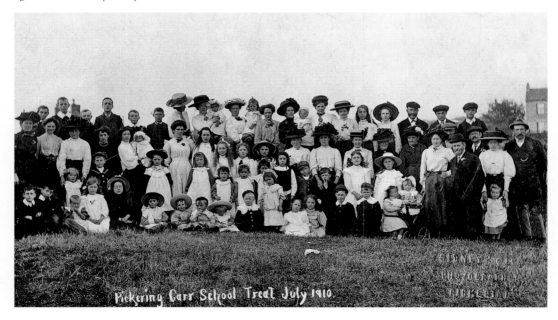

Pickering Carr School Treat July 1910

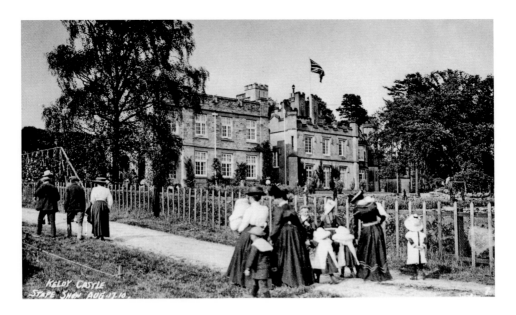

Keldy Castle

Women and children are on their way to Stape Show on 17 August 1910. The house was owned by the Reckett family; it had just been extended, but it was to be demolished in the 1950s. Below we see the reception office of Forest Holidays' Keldy cabins, north of Pickering. Fifty-nine holiday cabins have been constructed on land owned by the Forestry Commission (FC), the site of Keldy Castle. The company is a partnership between the FC and the Camping and Caravan Club. On 7 June 2010, member of staff Susanne demonstrates the amazing Segway Z2 scooter that visitors can hire while on holiday, watched by Zac, who is in charge of cycles and the Segway Z2s.

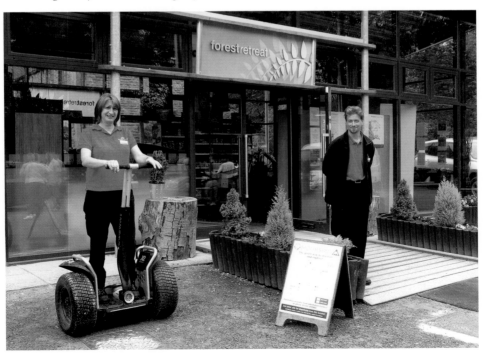

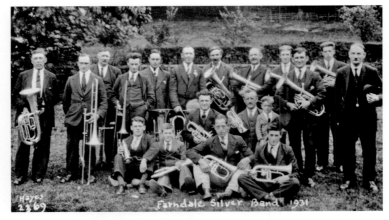

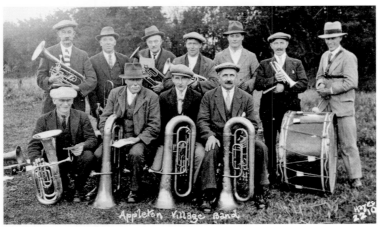

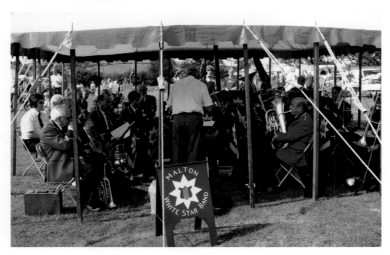

Village Bands (*Raymond Hayes of Hutton-le-Hole*)
Appleton Village Band (Appleton-le-Moors) and Farndale Silver Band in 1931. Both bands were photographed by Raymond Hayes or his father William. Today, some of the small village bands, including these two, have died out, but others have survived. On 8 August 2010 we see the Malton White Star Band, playing at the Rosedale Show.

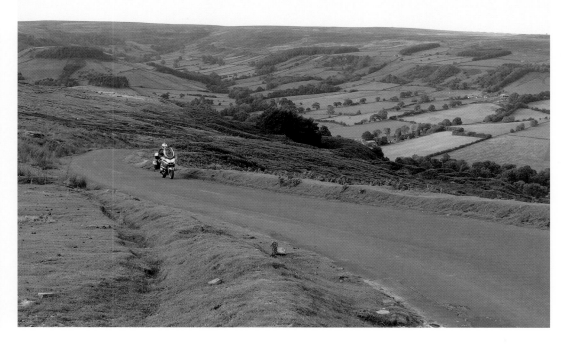

The Hill Climb (*Sydney Smith*)

A motorcyclist (below) rides up Chimney Bank, Rosedale, taking part in one of the many hill climbs organised by the Bradford Motor Club. The notorious 1-in-3 hill was used for both car and motorcycle hill climbs. The road is made of rough limestone and the track is marked out with tapes held in place with stones. Today, the hill is just as steep, but the road is well surfaced, and here Dave Harper makes light work of climbing the bank on his powerful BMW motorbike, but without the cheering crowds.

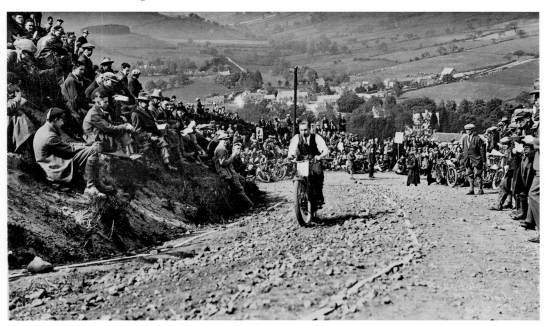

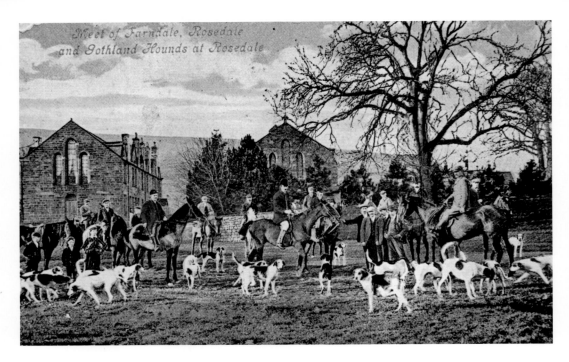

The Meet (*Tom Page of Rosedale*)
Farndale, Rosedale and Goathland hunts join up for the meet at Rosedale Abbey on approximately 29 October 1906. Today, the village has to cater for the vast number of visitors who flock to see this beautiful, unspoilt and historical place. On 3 July 2010, some people enjoy their ice creams, while others rest under the shady tree and look at the National Park notice board. The village school on the left is still open; next to it is the parish church.

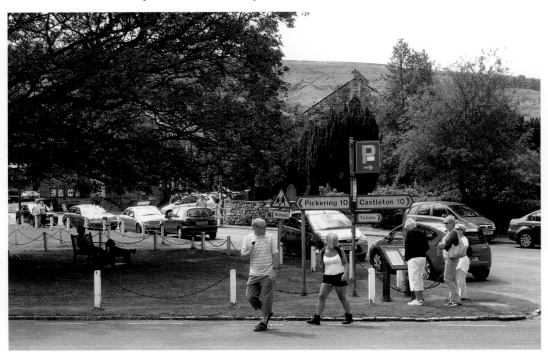

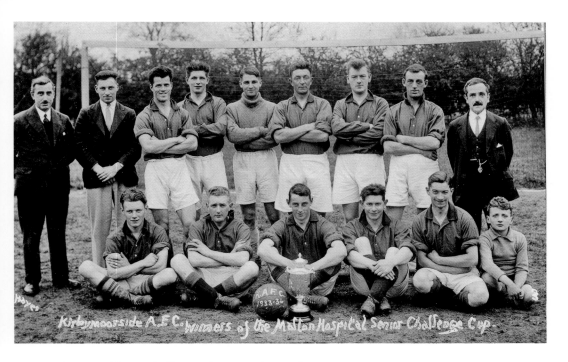

Kirbymoorside Football Team (*Raymond Hayes*)

Kirbymoorside AFC were winners of the Malton Hospital Senior Challenge Cup in the 1933/34 season. On 4 September 2010, Kirkbymoorside FC played Annfield Plain FC in the first round of the Monkwearside Charity Cup. The Moorsiders, as they like to be known, were playing (in red shirts) on their home ground, and went on to win 3–2. This was a good result after playing the same team a week earlier at Annfield and losing 2–1 in the Wearside League.

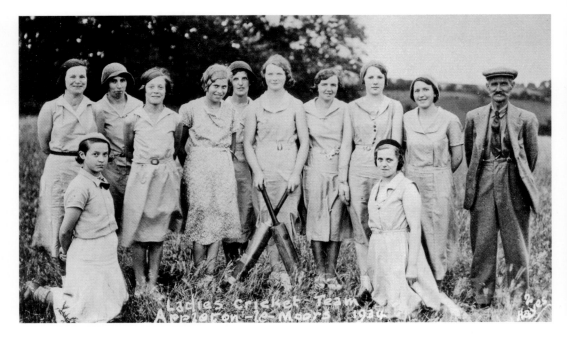

Ladies' Cricket Team (*Raymond Hayes*)

The village of Appleton-le-Moors shows off its ladies' cricket team in 1934. At the time, most towns and villages had teams of both sexes, taking part in local leagues. Village cricket is still popular today, but there are fewer ladies' teams taking part. Here we see a lone photographer taking shots of a cricket match on the Kirkbymoorside ground on 1 May 2010.

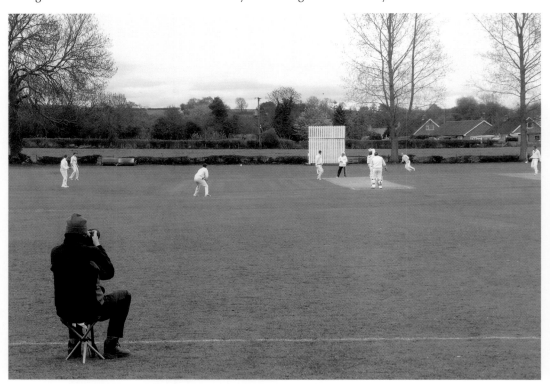

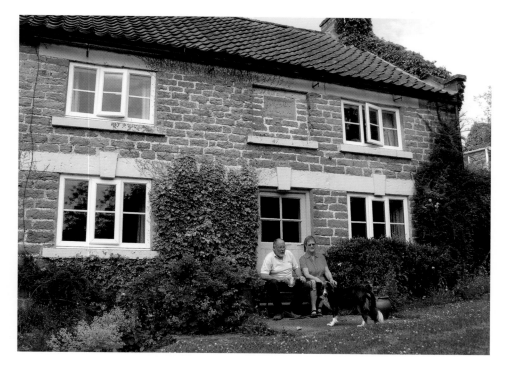

The Piano Fund (*Sydney Smith*)

The community of Stape near Newton-on-Rawcliffe, accompanied by Stape Band, stage a fund-raising event below in order to purchase a new piano for their village school. The piano was purchased for the children to sing around, but the school has since closed. The scattered community of Stape also had this public house called the Hare & Hounds, which was one of the last stops for refreshment before you crossed over the moors to Egton Bridge. The pub closed before the Second World War; here we see the present owners, David and Barbara Whitehead, sitting in their front garden with one of their dogs, Allie, on 2 July 2010.

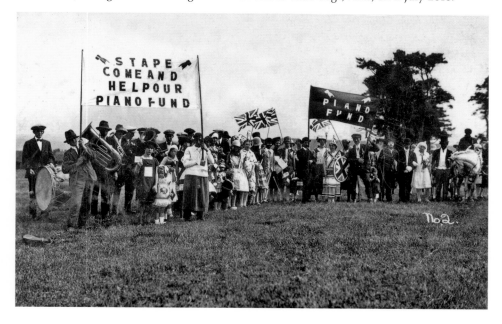

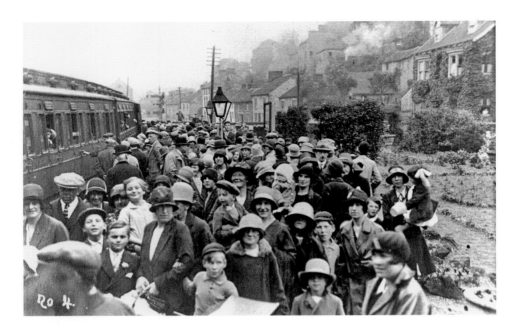

Sunday School Outing (*Sydney Smith*)

The annual Pickering United Church Sunday School outing is about to depart for Scarborough by train in 1929. Happy crowds of people fill the platform of Pickering station. On the 2 October 2010, the North Yorkshire Moors Railways are holding a Steam Gala Weekend, and the first engine to arrive at Pickering station is the special guest engine *Tornado*. This recently built engine took sixteen years to construct, and cost £3 million. Passengers are seen boarding their vintage teak carriages, recreating the old London and North Eastern train setting, getting ready for the return journey back up the line.

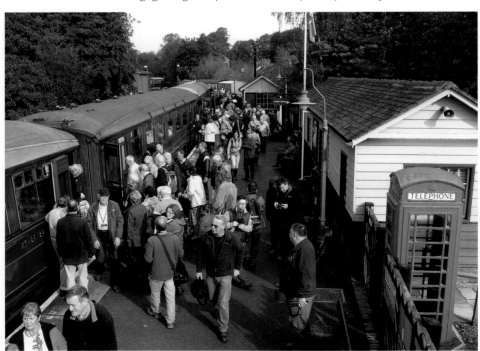

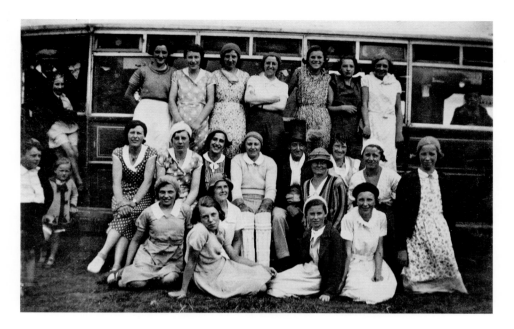

Ladies' Cricket Team and Pavilion

Newton-on-Rawcliffe ladies' cricket team, who played Normanby in 1933. In the background is the Newton pavilion which was formally a Leeds bus. It was purchased and moved to the village by Mr Webster, landlord of the White Swan public house in the village. Standing in the back row: Elizabeth Coultman, Violet Hill, Elsie Cross, -?-, Gladys Hill, Mary Atkinson, and Margret Aconley. Middle row: 'Nan' Hill, Eunice Hill, Hanna Barker (née Brewster) Doris Aconley, Mr Fox (umpire, in top hat), Alice Holtby, Meg Atkinson, and Lucy Humble. The ladies in the front row are unknown. The three children in the bus doorway are Alan Turner, Marjory Holtby, and Audrey HoItby. It is thought that today there are no local ladies' cricket teams playing in the area, but a lady from Lockton plays in a team near Leeds. Here we see cricket action at Lockton Village sports field on 1 May 2010.

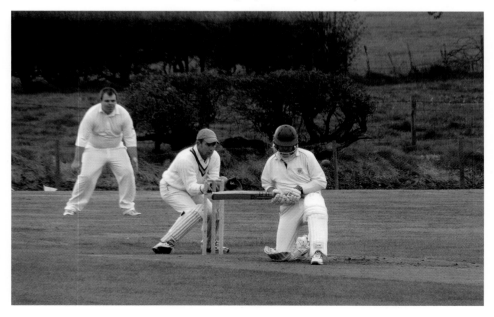

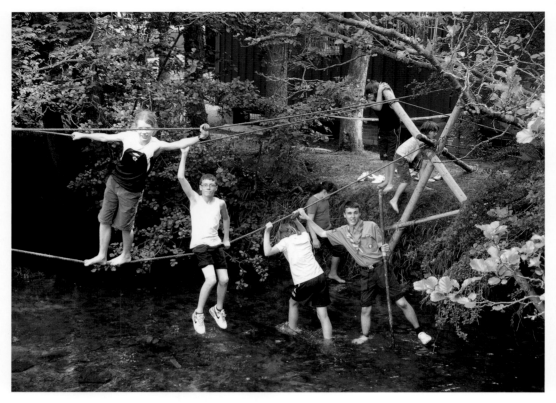

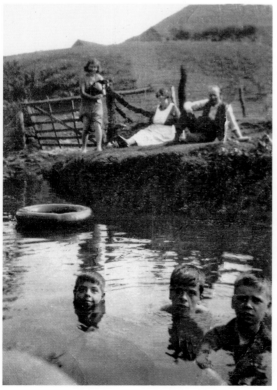

Bathing in the Beck, at Low Horcum
William and Eliza Mackley (left) are watching their sons Ron, Jack, and Walter in the stream, while daughter Mable, holding a dog, looks on. The farm was on the Pickering to Whitby road, near Saltersgate. The date is not known. Today, Ryedale families use the swimming pools at Pickering, Norton, and Helmsley, so that people no longer have to use the streams. On 26 June 2010, the First Vale of Pickering Scouts celebrated their 100th year in existence at their scout hut in Pickering. Above we can see some of them enjoying a rope bridge over Pickering Beck. This is the second hut on the site and, as a former member of the scout troop, I helped to raise funds and build the first one.

Chapter 5: Events

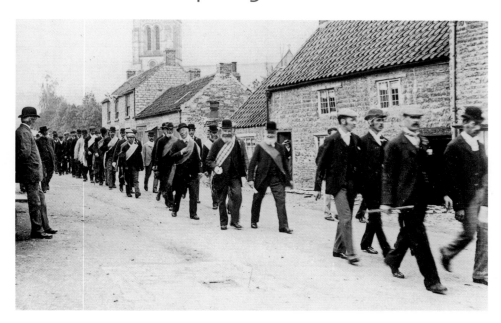

The Parade

A friendly society parades through Helmsley in 1887. Friendly societies provided sickness benefit for their members, who would pay a contribution into the fund of a few pence weekly. The modern friendly society to visit Helmsley is the thousands of motorcyclists who visit the town, some of whom can be seen below in the marketplace on 16 May 2010, taking a break from riding their expensive machines.

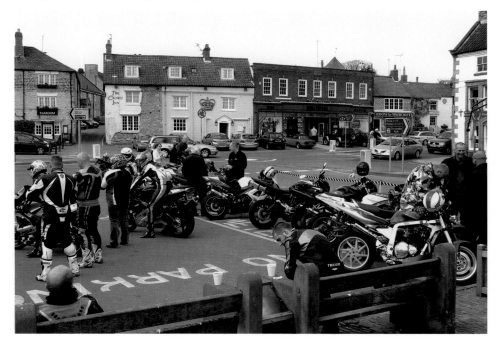

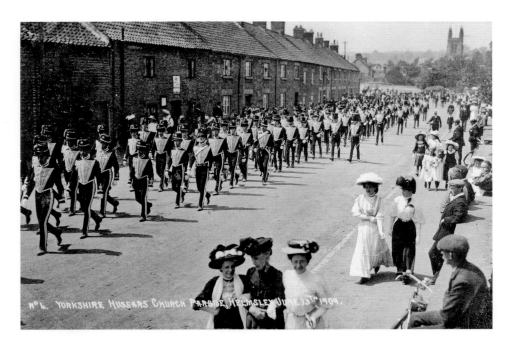

The Yorkshire Hussars Parade

The Yorkshire Hussars march through Helmsley on their Church Parade on 13 June 1909. The photographer is unknown. A hundred years later we can inspect the 68th Durham Light Infantry Display Team, marching in a Napoleonic re-enactment weekend in the grounds of Ryedale Folk Museum at Hutton-le-Hole on 27 June 2010. The society demonstrates military and camp life as it was in 1814.

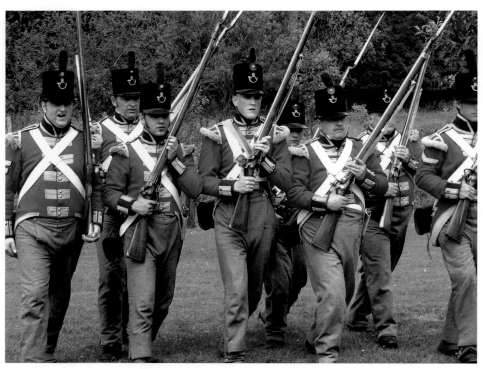

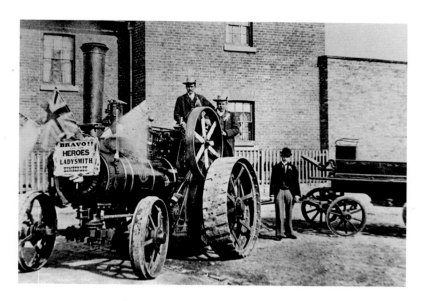

The Relief of Ladysmith

This traction engine is taking part in the Celebration Parade through the streets of Pickering, and is thought to be near the stationmaster's house and coal yard (near the traffic lights). A Wallis and Stevens engine, No. 2425 or 2476, is pulling the town's fire engine. The engine owner was Tom Garbutt of Pickering, the driver is Francis Edwin Craggs of Ebberston. The Siege of Ladysmith, in South Africa, during the Second Boer War, followed the Battle of Ladysmith, when Boer forces surrounded the town. The siege lasted 118 days, from 2 November 1899 to 28 February 1900. During the most crucial stage of the war, a total of 3,000 British soldiers died during the siege. Three attempts to break out resulted in defeat for British forces before General Sir Redvers Buller VC finally broke the siege after defeating the Boers on 28 February 1900. The stationmaster's house was demolished in 2008 to make way for a new supermarket, yet to be built. Here we can see the magnificent Earl Kitchener Showmen's engine in Pickering marketplace, having moved up from the show field on the Saturday evening to give the local inhabitants a free preview. They were all taking part in the annual Pickering Traction Engine Rally on 7 August 2010.

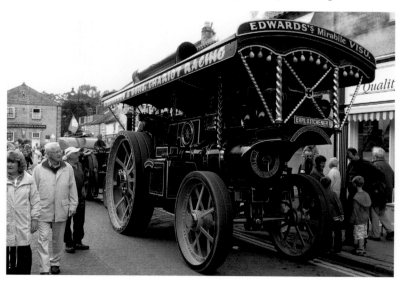

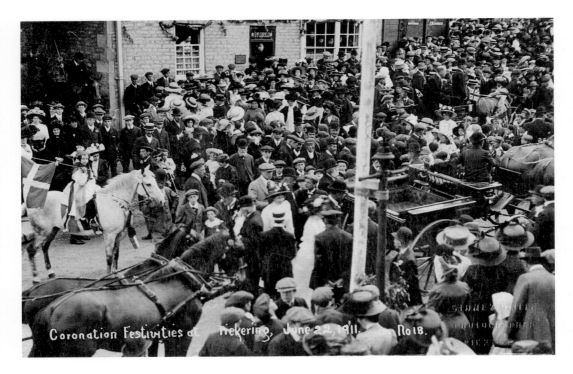

Coronation Festivities at Pickering (*Sydney Smith*)
This took place on 22 June 1911 for King George V. Crowds of people fill the marketplace outside the White Swan Hotel. The white pole behind the horse-drawn trap is a slippery pole, which men and boys would be encouraged to climb to the top of. On 13 June 2009, a crowd of happy people enjoy music in the marketplace, being played from a lorry trailer which provided a stage for live bands taking part in the town's 1960s music festival.

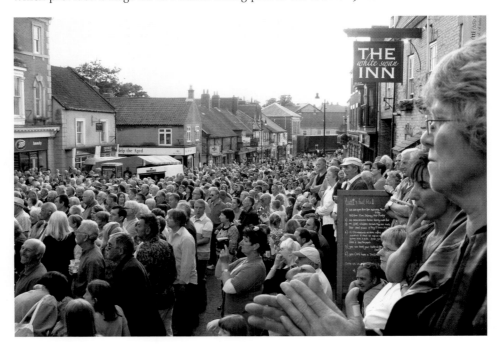

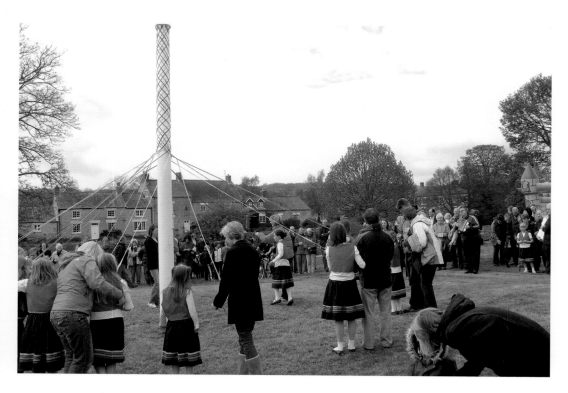

The Maypole (*Raymond Hayes, 25 May 1929*)

Workmen and volunteers with ropes are raising the new maypole below on the village green in Sinnington. On 3 May 2010, the villagers get together to stage a maypole festival, when the village green is used to raise money for local charities, and the maypole is brought back into use by school children.

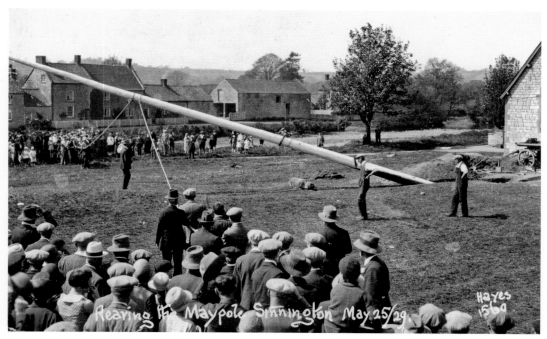

The Landslide (*Sydney Smith*)

A team of workmen below are removing grass and soil by hand from the tracks into railway trucks, following a landslide onto the Pickering to Kirbymoorside railway line, near Riseborough Bridge. The railway line was closed in 1963 as part of the Beecham railway closure programme, and the line lifted. But today, sheep graze on the grass embankment, which is still unstable and held in place with the self-seeded ash trees.

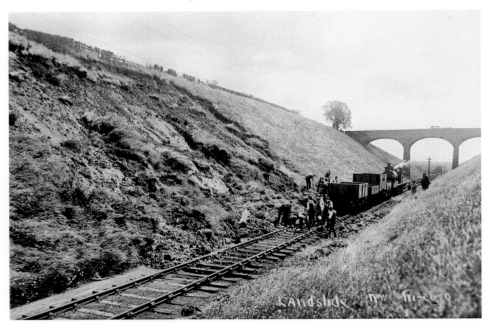

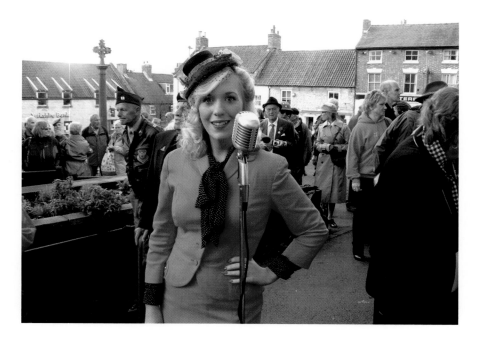

Election Fever (*Sydney Smith*)

This large crowd of people below fill up Smiddy Hill in Pickering for the parliamentary by-election, which took place on 1 May 1931. Ventress butcher's shop can be seen in the background. On 16 October 2010 the North Yorkshire Moors Railway staged its eighteenth Railway in Wartime weekend in Pickering, when over 20,000 visitors and re-enactors, and their authentic vehicles, travel back in time to remember the role played by our railways during the Second World War. Events are staged over three days, and on the Saturday we find the lovely Marina Mae singing to the crowds outside the Liberal Club on Smiddy Hill. Events take place all over the town, organised by the NYMR and local organisations, and a parade of military vehicles and re-enactor groups takes place on the Saturday.

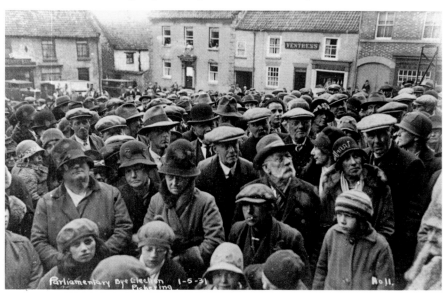

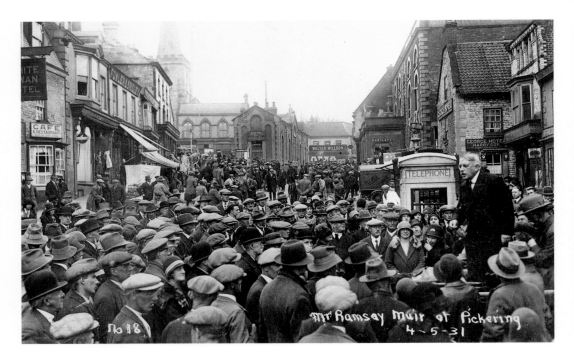

Ramsey Muir at Pickering (*Sydney Smith*)

Ramsay Muir was elected as a Liberal MP for Rochdale in the 1923 general election. He was defeated in the 1924 election, and stood for the Liberal Party during the 1931 parliamentary by-election for the Scarborough and Whitby division. On 4 May 1931, he addresses the crowds in Pickering marketplace, and was supported by David Lloyd George, but failed to win the seat. The modern photograph shows the Wartime Weekend, just after the parade has taken place on Saturday 16 October 2010.

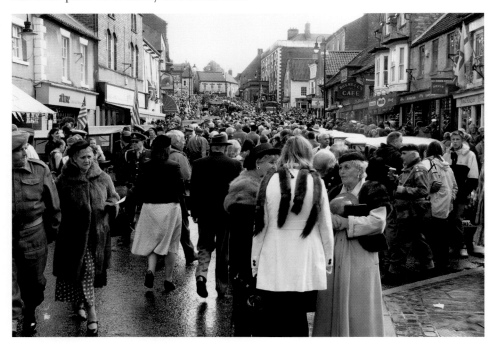

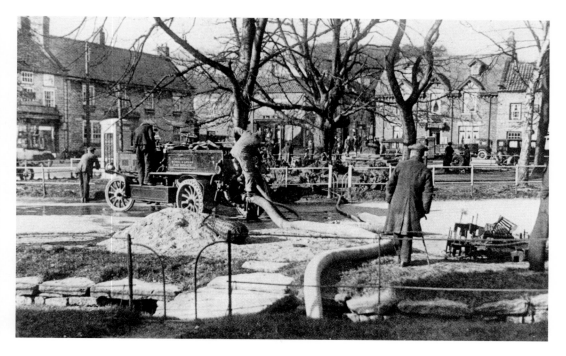

Fire at the Corner Shop

Firemen from Pickering Urban and Rural District Fire Brigade fight a fire at the Corner Shop, Whitbygate, Thornton Dale. They are pumping water out of the stream and across the village green and two roads in order to put out the blaze. The year was 1932. None of the firemen are wearing uniforms. On 22 April 2010, contractors working for the NYCC Highways Authority are installing a new bus shelter on the village green, watched by visitors.

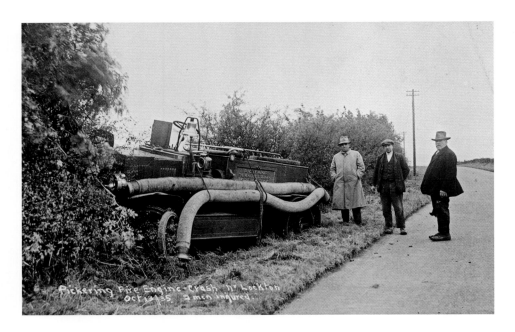

Fire Engine Crash (*Sydney Smith*)

On 13 October 1935, the Pickering fire engine crashed near Lockton, injuring two firemen. Joe Taylor of Pickering received a broken arm. Three men from the village survey the wreckage near the first lane into Lockton on the Pickering to Whitby road. The fire engine had been presented to Pickering Urban and Rural District Councils in 1926 by Alderman Twentyman from Kirby Misperton Hall. Here is Pickering fire station on 4 August 2010, part of the North Yorkshire Fire and Rescue Service. Crew manager Stuart Moss puts his crew of retained firemen through their paces on Wednesday's practice night at their station in Malton Road, Pickering.

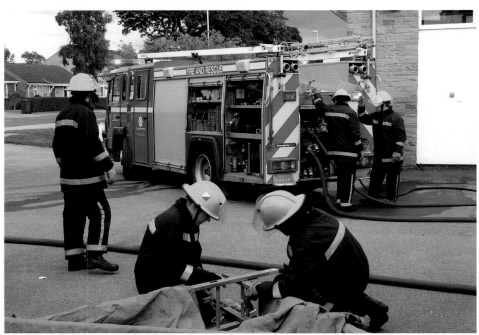

Chapter 6: Transport

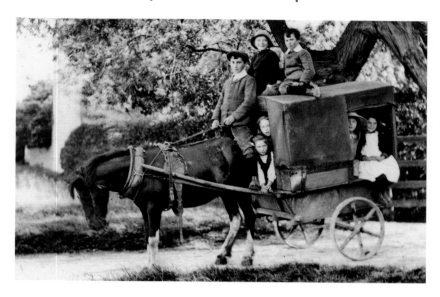

School Transport, 1908

William Botterill of Yedingham Cottage Farm built this covered pony cart to transport his children to Yedingham School in bad weather. The horse was stabled at the farm opposite the school during school hours. From left on top of the cart are: Jim Botterill, aged ten, Charlie Botterill, aged seven, and Frank Botterill, aged nine. The girls inside are: Mollie Botterill, -?-, -?-, -?-. The three unknown girls would be from adjacent farms along Kirby Lane. It is interesting to know that the great-great-granddaughters of one of the Botterill children are now running a successful coach business in Thornton-le-Dale, which includes the school bus service. On 6 September 2010, one of their drivers, Doug Jemison, delivers children back to Lockton village, near Pickering. Double-decker buses owned by a different company are also in use for the school journeys at Kirkbymoorside.

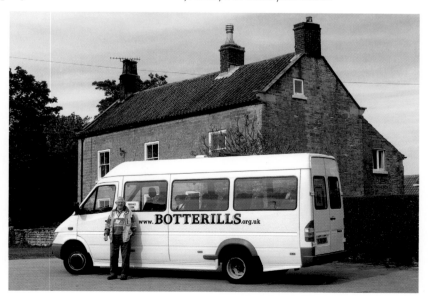

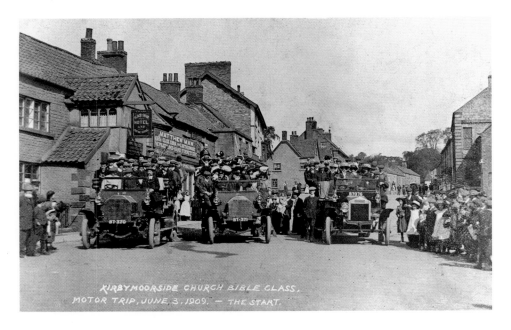

KIRBYMOORSIDE CHURCH BIBLE CLASS.
MOTOR TRIP, JUNE 3, 1909. — THE START.

Bible Class Motor Trip (*Wilf Lealman, photographer of Kirbymoorside*)
Three loaded charabancs are about to depart from Kirbymoorside for a trip to Scarborough.
The Church Bible class is starting from outside the Black Swan. The coaches were owned
by the railway company and transported from York to Kirbymoorside by rail. Instead
of leaving the town, crowds of people flock to take part in the tenth annual 10k run on
2 May 2010. Five hundred runners were expected to take part, with entry money going to
local schools. The run is about to start at 2.00 p.m.

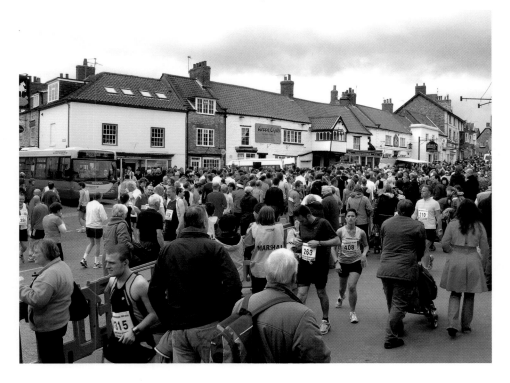

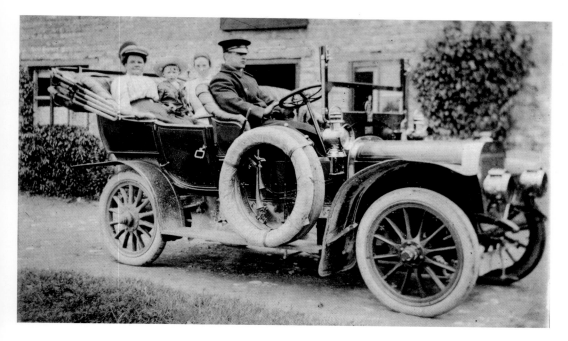

The Car Outing

This car is about to set off from outside the Blacksmith's Arms public house in Aislaby, near Pickering. The driver is the landlord William Agar Simpson. The passengers are unknown. Today the pub has closed and is waiting to be turned into dwellings. Stuart Hill sells fish and chips from his mobile shop in front of the public house, assisted by Lynne Olde on 4 May 2010. They travel around several local villages supplying this welcome meal.

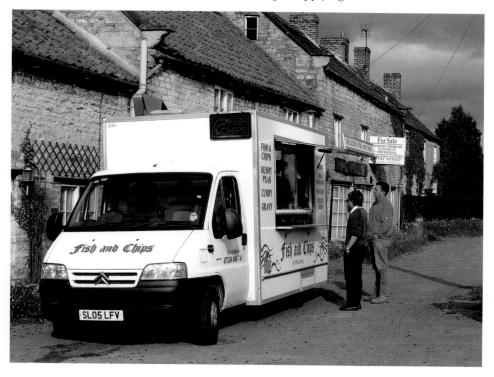

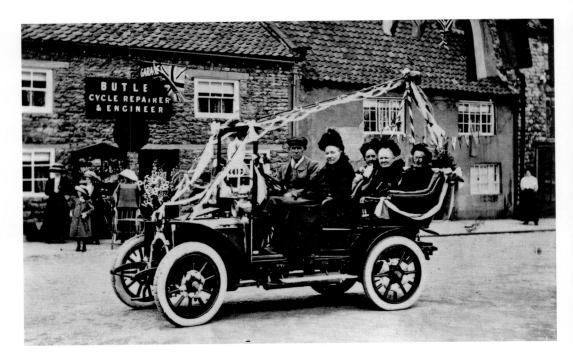

The Decorated Car Ride

Mr H. Butler is giving a ride to some of Helmsley's oldest residents. His car has been decorated – perhaps for a coronation, as the photograph was taken before 1913, when a new window was fitted to his garage behind the car. Nearly a hundred years later, cars and motorcycles of every colour fill all the parking spaces in the marketplace in this popular town, and a parking attendant makes sure they make room for more visitors on 17 June 2010.

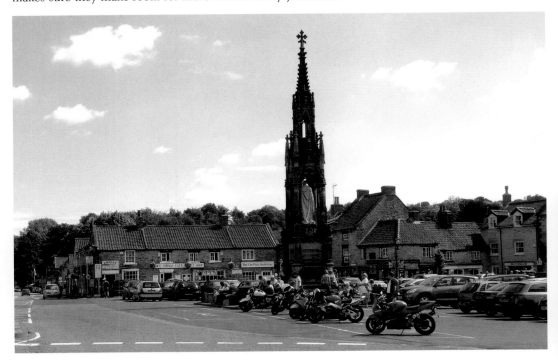

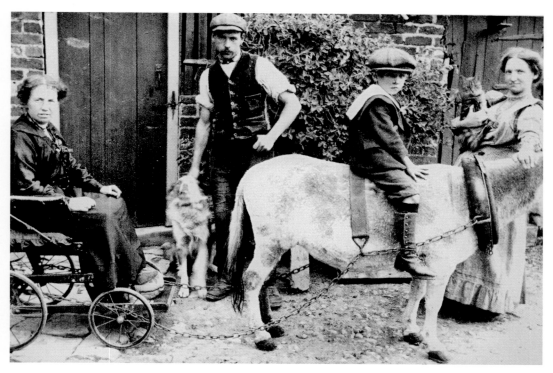

Donkey Power, 1915

This donkey has been yoked up in order to pull the lady in her chair outside the blacksmith's shop in Thornton-le-Dale. Alice Bennison Robinson is sitting in the chair, Edwin Hudson Rodger is the blacksmith, Stanley Charles is sitting on the donkey, and Alice Bennison Roger is holding the cat. Donkey power has now given way to battery power, and here we see Margret Jenkinson on her mobility scooter; she is taking a break from handing out Pickering town guides and museum leaflets, and is resting in the front garden of Pickering's Beck Isle Museum on 22 May 2010.

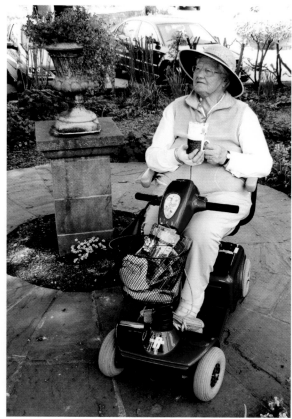

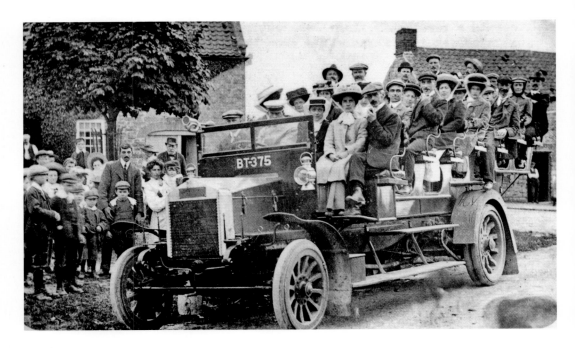

The Charabanc Outing

This early coach trip was about to set off from Gillamoor, near Kirbymoorside. Most of the charabancs at the time were owned by the railway companies and had canvas roofs which folded down at the back. The occasion could have been a Sunday School outing, but it has not been recorded. Below we can see villagers Mr and Mrs Simpson relaxing on the village green. The new tree on the right has replaced two earlier ones that had been removed due to being diseased. The Royal Oak public house can be seen in the background in this photograph, taken on 21 June 2010.

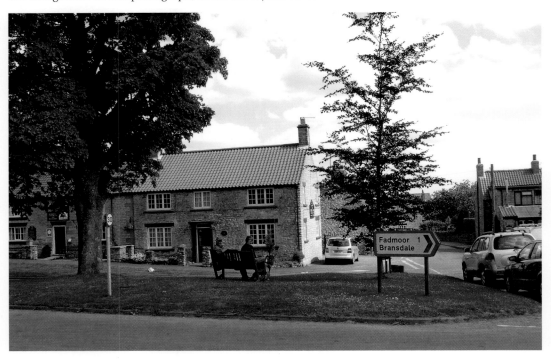

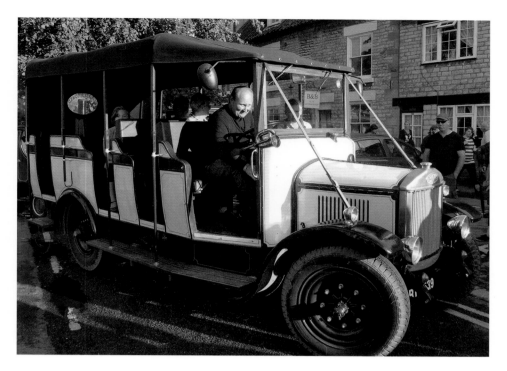

Pickering Outing (*Sydney Smith*)
Two loaded charabancs are about to depart below from outside Dennis House, at the top of Eastgate, Pickering. The small crowd of people on the right are standing outside the old police station. Just a little further down Eastgate, on 7 August 2010, we can see a Dennis bus, driven by its owner Mick Johnson, about to drive his family back to Pickering Show Field in Malton Road. The occasion was the Pickering Traction Engine Rally; on the Saturday night, some of the historic vehicles travel into town to show off their fantastically restored motors of all kinds to an admiring audience.

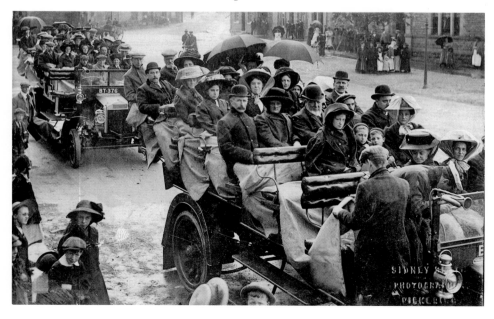

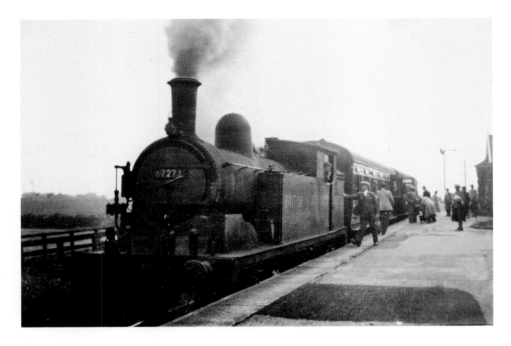

The Last Train Home

Passengers board the last train to leave Thornton-le-Dale station. It was 7.20 p.m. on 3 June 1950. The train was known as a 'push and pull' engine. It is thought that the line was used to carry limestone from the local quarry for a short time longer. The line has since been removed but the railway station is now a successful caravan site and holiday cottage. Just over sixty years later, on 20 June 2010, two holiday guests relax on the old platform in the lovely sunshine.

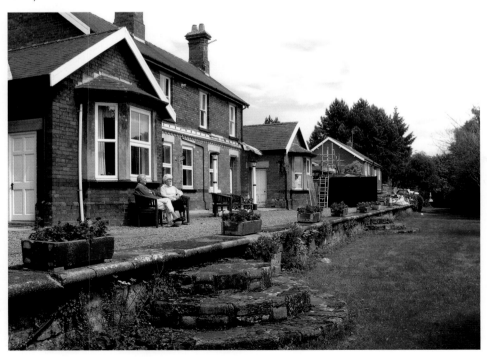

Chapter 7: The Weather

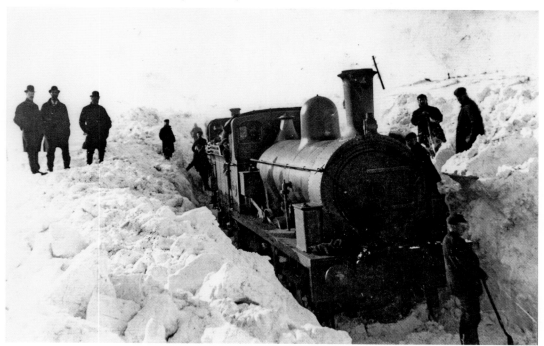

The Derailment

Workmen dig out snow by hand in order to free up a locomotive that has lifted off the rails with the snow at the Rosedale Ironstone Mines in around 1900. Three engines were used to push the snow plough over the moors in order to remove the iron ore by rail. In order to prevent a derailment, which would stop ore removal, the last engine was turned around, allowing it to go backwards and forwards, see-sawing through the snow drifts. This photograph is thought to have been taken by Thomas Smith of Rosedale. It is not possible to recreate this photograph, as the Rosedale Ironstone Railway closed in 1926 and little of it remains. So I have moved down to the North Yorkshire Moors Railway at Pickering station, where steam locomotives can be seen entering and leaving to make journeys up the line to four stations and even to Whitby Town. This is the famous steam locomotive *Repton*. Beth, the driver or fireman, takes the controls before making the return journey on 13 June 2010.

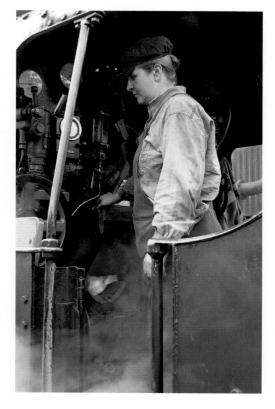

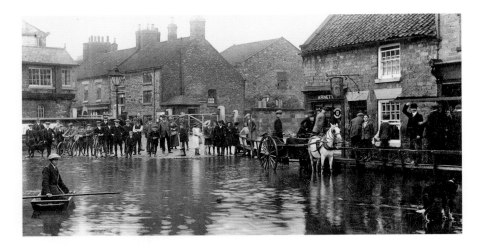

Flood at Pickering (*Sydney Smith*)

Floods hit the bottom of the marketplace in July 1914. A pony and trap along with a man sailing a wooden scalding tub (used for removing hair from slaughtered pig carcasses) pass through the floodwater, watched by the crowd. Arnetts cake shop and café is on the right, and the railway signal box and Bridge Street crossing gates can be seen in the background. The same area flooded again in June 2007, but here we see volunteers Mike Haigh and Hilda Sissons from Beck Isle Museum manning a publicity stall on the site of the demolished railway signal box. The Victorian tricycle was made by a local engineer, Robert Dobson, who had an implement works and cycle depot in Hallgarth. It was restored in its original colours and was thought to have been used in a circus. It was the evening of 23 April 2010 when mountain bikes took to the town's streets in the Pickering Pro Sprint Eliminator bike race, part of the 2010 UCI Mountain Bike Cross-Country World Cup, held in Dalby Forest, near Thornton-le-Dale.

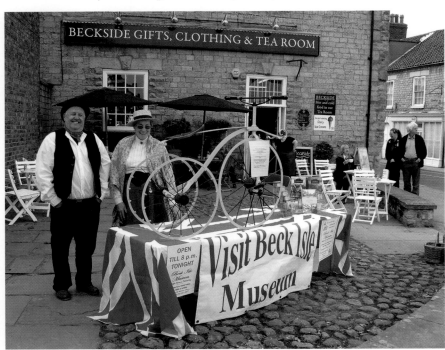

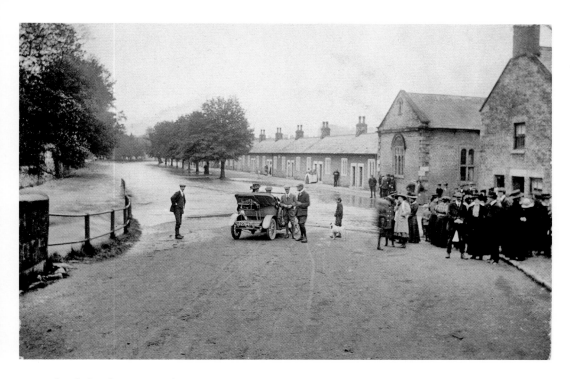

Floods in Thornton Dale

A crowd of people stand near the bridge while floodwater spills over the main Pickering to Scarborough road. The line of trees called 'The Avenue' can be seen on the right, along with the Alms Houses. Little has changed today, but the trees have been replaced and cafés have opened that sell ice cream, while the Alms Houses have been improved and are still occupied.

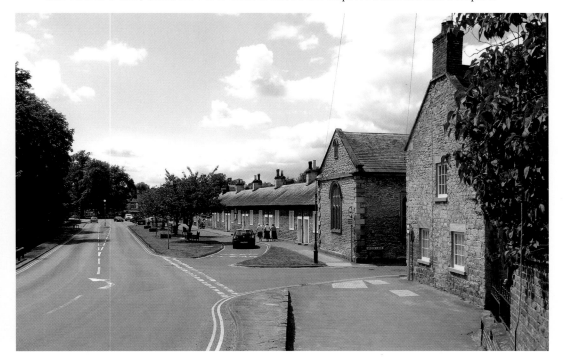

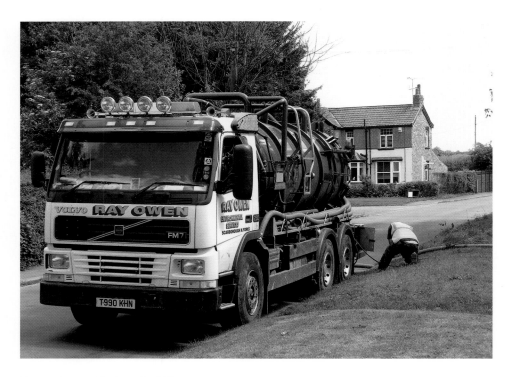

Horse Power (*Sydney Smith*)

Floods in Sinnington below on 7 September 1927. Two men with a horse pull a car out of the floodwater. This scene was repeated all over Ryedale and would be a good little earner for the farmers who carried out this cold and wet job of work. The village still suffers from flooding and was devastated in 2007. Here we see a waste-water tanker removing sewage effluent from the village sewage pumping station, now sited on the same location, on the right-hand verge. This vital work prevents flooding of a more unpleasant nature.

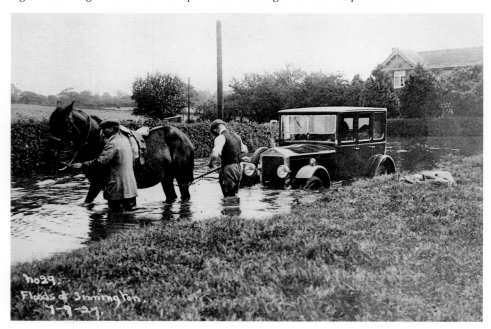

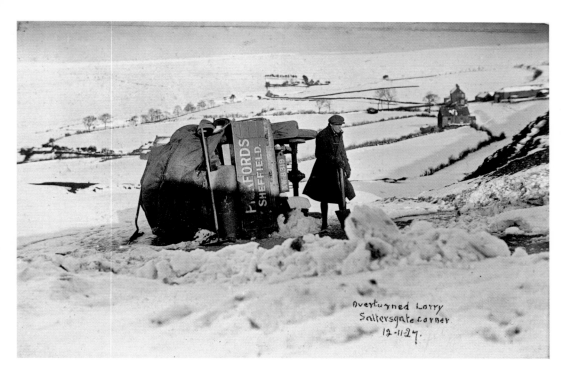

Overturned Lorry
Saltersgate corner
12·11·27.

Overturned Lorry (*Sydney Smith*)

This Pickfords lorry from Sheffield came to grief when it overturned on Saltersgate Bank, on the Pickering to Whitby road. The date was 12 November 1927. Today, the bank is much safer, and even in winter poses no problems to modern heavy goods vehicles. Also the edge of the road has been fitted with a steel crash barrier. RAF Fylingdales can be seen on the skyline.

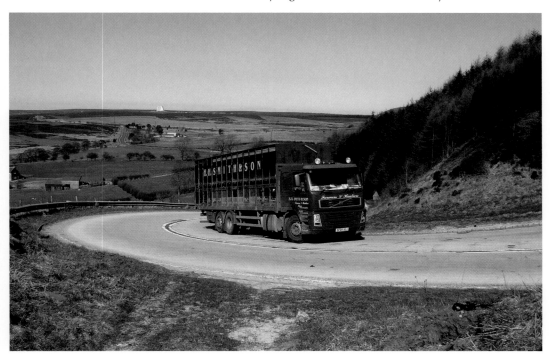

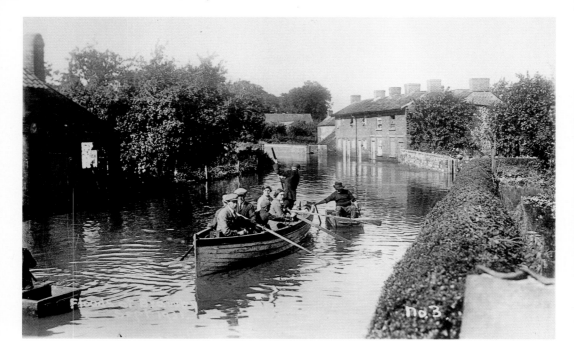

Floods at Brawby (*Sydney Smith*)

Villagers using a rowing boat and makeshift boats made from wooden scalding tubs pass down the village street in September 1931. The man in the tub holding onto the boat is Jerry Pickering. Today, the cottages on the right have been demolished and replaced by modern bungalows. On the left, Alan Bradshaw and Laurie Thackray are outside their Rye Valley Engineering Works on 30 June 2010.

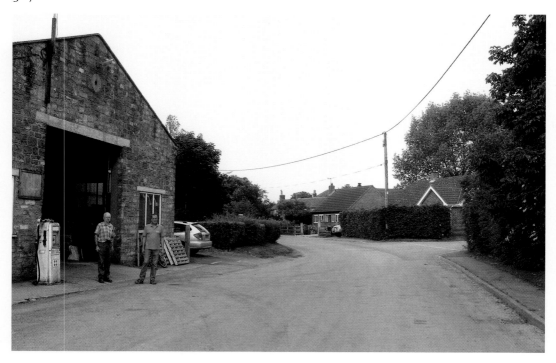